EDWARD HOPPER

My aim in painting is always, using nature as the medium, to try to project upon canvas my most intimate reaction to the subject as it appears when I like it most; when the facts are given unity by my interest and prejudices. Why I select certain subjects rather than others, I do not exactly know, unless it is that I believe them to be the best medium for a synthesis of my inner experience.

Edward Hopper

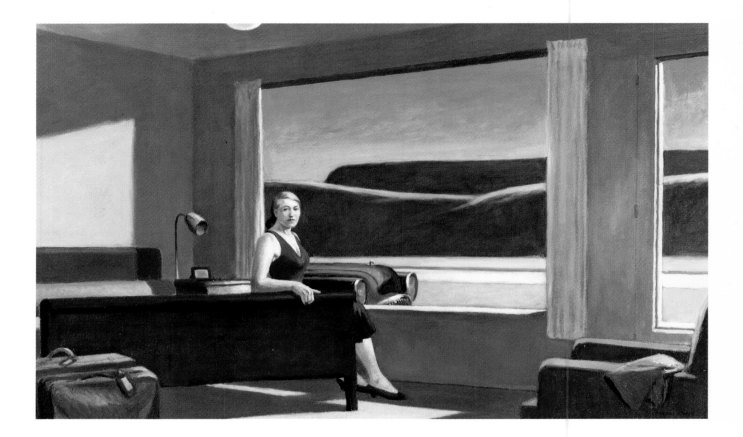

Edward Hopper

ROBERT HOBBS

Harry N. Abrams, Inc., Publishers, New York
IN ASSOCIATION WITH
The National Museum of American Art, Smithsonian Institution

This book is dedicated to Corinne

Series Director: Margaret L. Kaplan
Editor: Anne Yarowsky
Designer: Michael Hentges
Photo Research: John K. Crowley

Brackets in caption information indicate descriptive titles given to works that were untitled during Edward Hopper's lifetime.

Excerpts on pages 19, 107, 110, 129, 139, and 146 are from Edward Hopper's Record Books (4 vols.), in the collection of the Whitney Museum of American Art, New York City; Gift of Lloyd Goodrich. The complete Record Book entries will appear in the forthcoming catalogue raisonné of Hopper's works by Gail Levin, to be published by the Whitney Museum of American Art in association with W. W. Norton & Co.

Library of Congress Cataloging-in-Publication Data

Hobbs, Robert Carleton, 1946–
 Edward Hopper.

 (The Library of American Art)
 Bibliography: p. 152
 Includes index.
 1. Hopper, Edward, 1882–1967. 2. Artists—United States—Bibliography. I. National Museum of American Art (U.S.) II. Title. III. Series.
 N6537.H6H6 1987 759.13 [B] 86–32276
 ISBN 0–8109–1162–0

Frontispiece: *Western Motel,* page 98

Times Mirror Books

Printed and bound in Japan

Contents

Acknowledgments

THE STAFFS of four institutions have contributed enormously to the research and production of this book. They have all given unstintingly of their time and have been equally generous with their expertise.

First I would like to thank the very enlightened administration of the University of Iowa, particularly Vice President Richard Remington and Dean Fredrick Woodard, who encouraged me to continue my research at the same time that I was directing the Museum of Art. And the entire Museum staff has consistently supported this project even though it necessitated that I take time away from the Museum. Karen Heuftle, then a graduate student at the University and part-time employee at the Museum, was a superb research assistant, who patiently worked to find many sources that have long been out-of-print. Without her help this project would never have been realized. Nancy DeDakis and Eva Huber have been dedicated, uncomplaining typists who have dealt with succeeding drafts and sprawled marginalia with equanimity.

Tom Armstrong, director of the Whitney Museum of American Art, has made available the full resources of his institution. He has been enthusiastic about this project and my new approach to Hopper's work. It has been a pleasure to work with the entire Whitney staff. In particular, I wish to thank Deborah Lyons for so generously sharing her expertise, Doris Palca for her encouragement, and Dennis Evans and Alan Myers for providing a congenial environment in which to study specific paintings by Hopper.

This Hopper book is part of a series that is jointly sponsored by The National Museum of American Art and Harry N. Abrams, Inc. The staff of The National Museum of American Art takes its role in this project very seriously and has provided excellent, in-depth readers' reports, which have helped enormously.

The staff at Abrams has been superb. Margaret Kaplan, whose brainchild is this series, has been consistently supportive and professional. Anne Yarowsky has been a pleasure to work with; as has John Crowley. Both have made the final editing and production a smooth and thoroughly enjoyable process.

Finally I wish to thank several friends: Dee Eaker for her confidence in this project, Dorothy Schramm for her pertinent suggestions, John Scofield and Karen Bussolini for their encouragement, and Gaylord Torrence for his response to several ideas developed in this book.

ROBERT HOBBS

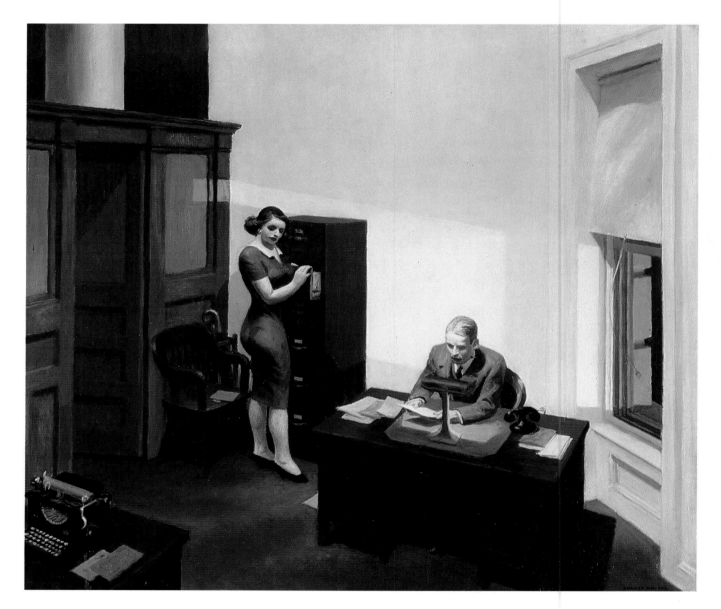

Office at Night

INTRODUCTION
I. Vision, A Historical Artifact

EDWARD HOPPER mined his uneventful life and found poetry in the prosaics of the modern world. After a few years of study with William Merritt Chase, Kenneth Hayes Miller, and Robert Henri, followed by three trips to Paris in the years 1906–10 and a long stint as a commercial illustrator, Hopper's life settled into the routine of a patient observer of change.

Hopper was born in Nyack, New York, in 1882. In 1913 he moved to 3 Washington Square North, New York City, where he lived until his death in 1967. In the teens and twenties he spent summers in Gloucester, Massachusetts, and Ogunquit and Monhegan Island, Maine—all favorite retreats for vacationing artists. He married the painter Josephine Verstille Nivison in 1924; the two bought a Dodge in 1927, and over the years they made several cross-country trips. In 1934 they built a summer house in South Truro, Massachusetts, on Cape Cod, where they spent six months out of almost every year for the rest of their lives. Even though Edward Hopper began to enjoy in the mid-1920s a comfortable income from the sales of his art, the Hoppers lived frugally; they wore clothes purchased at Woolworth's and Sears, and their only extravagances were books, films, and plays.

In 1924, when he was forty-two years old, Hopper was given a one-person show at the Frank K.M. Rehn Gallery. All the works in the Rehn Gallery exhibition sold, and Hopper's art became an overnight sensation in the art world. Although success seemed to mean little to him, it permitted him more time to paint because he could now give up his job as a commercial illustrator. Success also meant that Hopper could have his first retrospective exhibition at The Museum of Modern Art in 1933. Nevertheless, Hopper remained distrustful of popularity throughout his life.

Hopper's remarkable following did not encourage him to step up the production of his art. He painted slowly; he waited for inspiration, and he usually completed only one or two paintings a year. He said that a painting was almost completely established in his mind before he began to paint it. His art was the result of a long and painful period of allowing various im-

Office at Night

1940. Oil on canvas, 22⅛ × 25″
Walker Art Center, Minneapolis
Gift of the T. B. Walker Foundation,
Gilbert M. Walker Fund, 1948

This painting characterizes the repression and vulnerability of the locked-out generation that came to maturity during the Great Depression.

9

pressions to form a synthesis, and then it was a patient and equally difficult time of trying to re-create that synthesis, a process of finding painterly equivalents for the vision he held. "I find, in working," Hopper wrote in The Museum of Modern Art catalogue, "...the disturbing intrusion of elements not part of my most interested vision, and the inevitable obliteration and replacement of this vision by the work itself as it proceeds. The struggle to prevent this decay is, I think, the common lot of all painters to whom the invention of arbitrary forms has lesser interest." In 1961 he reaffirmed this idea in a televised interview entitled "Invitation to Art" with the critic Brian O'Doherty when he mentioned that he carried in his billfold the following statement of Goethe:

The beginning of the end of all literary activity is the reproduction of the world that surrounds me by means of the world that is in me. All things being grasped, related, re-created, loaded, and reconstructed in a personal form, in an original manner.

Hopper added: "To me that [Goethe quotation] applies to painting fundamentally and I know that there have been so many different opinions on painting. Now, there will be many who protest that this is outmoded, outdated, but I think it's fundamental."

If the outward events of Hopper's life—except for his almost overnight acceptance as an important painter in the mid-1920s—are unremarkable, the inner world chronicled in his art is an intriguing story that parallels in many respects the history of the United States in the first half of the twentieth century. It is a story of an isolated individual dealing with the problems of advanced industrialization: as Hopper wrote in 1927, "It is something if a modicum of the brutal reality can be saved from the erosion of time." Hopper underscores his own interests in plumbing the ordinary in an article on the painter Charles Burchfield. After citing Emerson's statement "In every work of genius we recognize our own rejected thoughts," he describes Burchfield's art in a manner apposite to his own:

From what is to the mediocre artist and unseeing layman the boredom of everyday existence in a provincial community, he has extracted that quality we may call poetic, romantic, lyric, or what you will. By sympathy with the particular he has made it epic and universal. No mood has been so mean as to seem unworthy of interpretation; the look of an asphalt road as it lies in the broiling sun at noon, cars and locomotives lying in God-forsaken railway yards, the streaming summer rain that can fill us with such hopeless boredom, the blank concrete walls and steel constructions of modern industry, mid-summer streets with the acid green of close-cut lawns, the dusty Fords and gilded movies—all the sweltering, tawdry life of the American small town, and

behind all, the sad desolation of our suburban landscape. He derives daily stimulus from these, that others flee from or pass with indifference.

In this article Hopper also makes reference to "our native architecture with its hideous beauty, its fantastic roofs, pseudo-Gothic, French, Mansard, Colonial, mongrel or what not" and to "a sense of vast expanse beyond the limits of the picture" that are also characteristic of many of his own works. Unlike Burchfield who becomes romantic and nostalgic in his realistic landscapes, Hopper approaches these subjects with an understated rigor appropriate to the twentieth century.

Coming to prominence in the 1920s, in the heyday of the flappers and the first widespread use of the radio and the automobile, Hopper presented a new and poignant vision of America. Choosing not to paint the hustle and bustle or to delight in the anecdotal, he remained true to his stoic, calm self by discovering an equivalent of his inner state in the image of America that the automobile helped to produce. His paintings approach the disinterested casual glance of the tourist; they also emphasize streets, telephone lines, signs, intersections, gas stations, tourist homes and motels, as well as the out-of-the-way roads that provide views of run-down farms and deserted, boarded-up houses. The assumed spectator of these scenes may well be the taciturn and shy Hopper himself, but he or she is also one of the new inhabitants of the twentieth century who find themselves aliens in the world and as much a mystery to themselves as the world is a mystery to them.

Hopper merits a special chapter in the history of American art. He follows the art-for-art's-sake attitudes of Tonalism, a refined style that reacts to the closing of the American frontier by accommodating itself to twilit, intimate landscapes, to nostalgia, and to a refined aesthetic that recoils from the vulgarity of the gilded age and that questions the aspirations of a materialistic industrialized world. Hopper also comes after the Eight, a group formed in 1908 and composed mostly of illustrators-turned-painters led by Robert Henri, who reveled in New York City street life, in the influx of immigrants, and in the possibilities they provided for upsetting America's recently formed class structure. Unlike his artistic forebears, Hopper is the poetic distiller of the landscape of late industrialism. He is also the first chronicler of the views of America dictated by the automobile, and, most important, he is the first to understand the ramifications of the automobile, an invention that would serve to isolate people from each other and separate them from the country they hoped to escape to on weekends. At an early date he understood the ways that the automobile would transform America and make it psychologically as decentralized as present-day Los Angeles. This book is about Edward Hop-

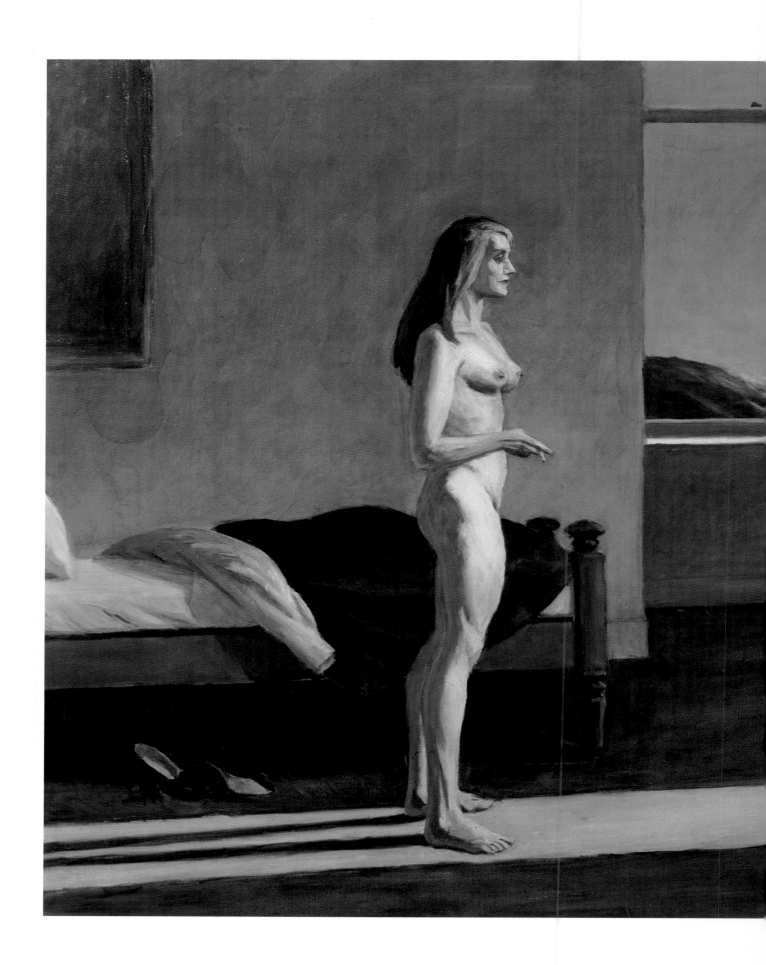

A Woman in the Sun

1961. Oil on canvas, 40 × 60″
Whitney Museum of American Art, New York City
50th Anniversary Gift of Mr. and
Mrs. Albert Hackett in honor of
Edith and Lloyd Goodrich
84.31

Several writers have referred to this painting as an Annunciation. The image, however, suggests isolation and resignation rather than a woman finding her place in the sun.

per's vision of a changing America, a view that is now so widely accepted that it requires some effort to grasp the truly innovative nature of this art which deemed change worthy of consideration.

The automobile's entry into American life permits a new outlook that differs radically from the point of view of the nineteenth-century American itinerant landscape painters who formed the Hudson River School. The earlier view was epitomized in Thomas Cole's painting *The Oxbow*. Situating himself high on a hill in the foreground of the painting with his easel, paintbox, and palette, Cole affirms the fact that the Oxbow is a picturesque subject that merits careful scrutiny and repeated periods of contemplation. He places himself in the land to suggest to art observers that they emulate his painstaking meditation on nature's wonders. Cole's attitude was enlarged upon by his student Frederic Edwin Church, who traveled several continents to find the quintessential vantage point. Although his grand paintings usually synthesized several scenes, he encouraged the idea that he had found a new and most profound view of nature. His descriptions of his trek to the volcano Cotopaxi in South America include a summary of the trees that were cut down to reveal the breathtaking scene that he immortalized in his art, a view never before witnessed by another human being.

The Hudson River artists' regard for nature as something grand and profound and as a subject worthy of detailed study was overturned by the American painters Theodore Robinson, who endorsed French Impressionism, and James A. McNeill Whistler, a proponent of the art-for-art's sake approach, who wished to capture not so much a view of a specific landscape as an image of the cursory glance that is characteristic of modern life.

Hopper transformed the sweeping glance of late nineteenth-century dandies who strolled along the recently formed grand boulevards of Paris to the strangely suspended gaze of motorists and moviegoers. Motorists simply watch nature as it unfolds before them; they do not note particular flora and fauna; they are more caught up in the continuity of the land than with specific scenes. One scene resembles another; the outing becomes the real adventure, and any single view is subservient to the speed of the car, the narrowness or width of the road, the weather, and the light. This unfeeling look, which Hopper captures in many of his works, is unsettling, for it presents a scene that is memorable by virtue of its commonplace appearance. People may have strong feelings about Hopper's art, but he does not give them clues that allow them to become immersed in the landscape, to view it as sublime, or to feel that it somehow represents a purer, untrammeled world and a higher morality. Nature, in Hopper's art, is surveyed by a disinterested twentieth-century viewer used to the continuum

Seawatchers

1952. Oil on canvas, 30 × 40"
Private collection

Even though the season is summer or early autumn, Hopper makes the sunlight look cold and wintry. The couple's resignation seems to capture the mood of many people in the United States who had gotten over post–World War II euphoria and found themselves caught up in the unresolvable conflict of the Cold War.

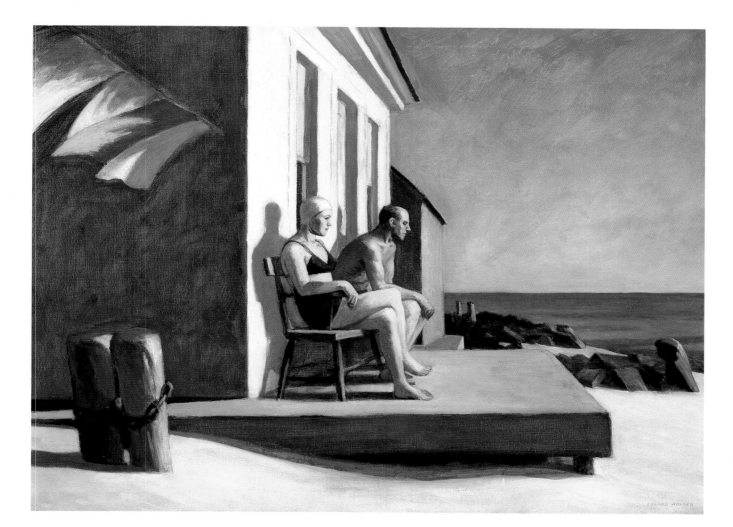

Seawatchers

that constitutes both a drive in an automobile and a film; and because it is little understood, nature becomes in the art a mysterious force, a symbol of the other. Hopper is the first artist to recognize that visual images in the twentieth century have become so common that they have also become expendable. He plays on the way individual images become prevalent in the twentieth century, and he memorializes in his art undistinguished scenes available to everyone. Frequently his images pay homage to the ubiquitous victims of progress by picturing abandoned country houses, weeds along railroad tracks, and desolate Victorian mansions.

In his art Hopper stops the narrative that constitutes a drive in an automobile or the montage of a movie to focus on strangely isolated stills. Seen by themselves, these stills are mysterious and haunting. They evoke a desire for the rest of the narrative, and they powerfully convey the breakup of the storyline, the disjunction that is characteristic of modern life. In this manner they awaken in the viewer a desire for the whole, and thus elicit feelings of isolation and loss. The feelings of loneliness experienced by viewers of Hopper's art, who sometimes use the term "desolation" to describe what they see, come from the fact that a continuum has been broken. The machinery of industrialism is no longer operative, and the illusion of progress as a motivating life force is no longer believable. By stripping modern life of its illusions of momentum, Hopper leaves his viewers isolated; he shows the breakdown of traditional spiritual underpinnings in the modern world and reveals the poverty of a society that has forsaken a meditative calm for a frenetic view of progress. The stills communicate a profound disbelief in the positive benefits to be obtained from constant movement. In Hopper's stills there are never enough clues to provide a definitive narrative; his mature paintings always emphasize their fragmentary state: they remain unsolvable question marks that indicate a profound distrust of the entire modern age.

In a letter written in 1948 to Norman A. Geske, who was then at the Walker Art Center, Hopper described the origin of *Office at Night* (1940) and indicated an awareness of his freeze-frame technique:

The picture was probably first suggested by many rides on the 'L' train in New York City after dark and glimpses of office interiors that were so fleeting as to leave fresh and vivid impressions on my mind. My aim was to try to give the sense of an isolated and lonely office interior rather high in the air, with the office furniture which has a very definite meaning for me.

Later he cryptically referred to the insoluble puzzle his art represented when he told his friend Lloyd Goodrich, then director of the Whitney Museum of American Art, that *Second Story Sunlight* (1960) "is an attempt

Second Story Sunlight

1960. Oil on canvas, 40 × 50″
Whitney Museum of American Art, New York City
60.54

In his art Hopper played with intimacy and distance: his people look like distinct individuals in spite of the fact that they are representative types. In Second Story Sunlight *Hopper contrasts youth and old age. Both people are at a remove from life even though the young girl is eager to get off the balcony and become a part of life while the woman is content to remain a spectator.*

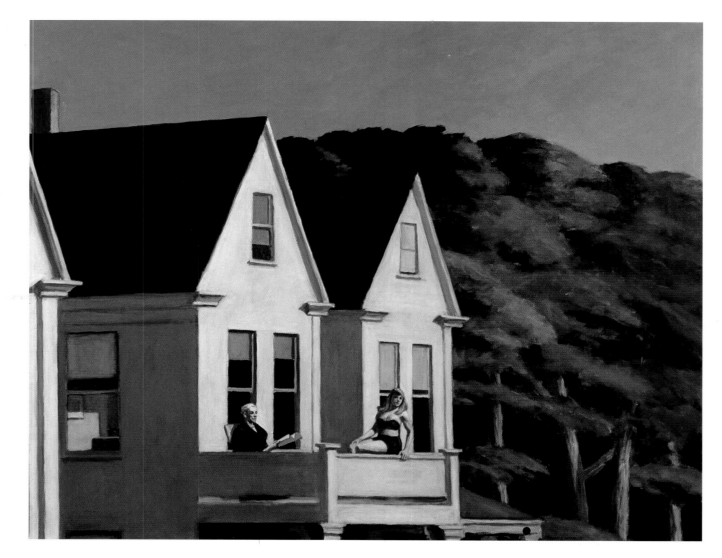

Second Story Sunlight

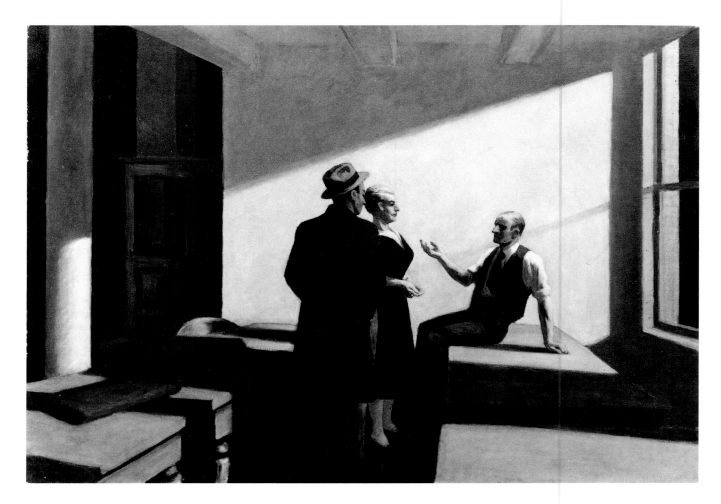

Conference at Night

to paint sunlight as white, with almost or no yellow pigment in the white. Any psychologic idea will have to be supplied by the viewer." And in response to a question by Brian O'Doherty regarding the content of his art, Hopper responded, "I can't always agree with what the critics say. You know, it may be true or it may not be true. It's probably how the viewer looks at the pictures. What he sees in them. . . . That they really are."

Both Edward and Jo Hopper tried to compensate for the isolation and fragmentation reflected in his art by assigning names and identities to some of the characters in the paintings and by giving nicknames to the paintings themselves. In the ledger books that Jo kept over the years to record paintings leaving the studio, *Office at Night* is called "Confidentially Yours Room 1005" and the woman in the work is referred to as Shirley (Vol. II). When describing *Conference at Night* (1949), Jo notes that "Deborah is blond, a queen in her own right. Heavy table golden oak. Big green ledger with dull red edge. Sammy better looking than here in drawings" (Vol. III). This game of storytelling was probably initiated by Jo, who was as garrulous as Edward was taciturn, but it is clear from the entries here that the artist joined her in trying out roles for his figures:

Sea watchers—*Sheila and Adam, Irish girl, gentle, sweet, large—Yankee clam digger— very fine people—on New England coast for late swim. People inventions of E.H.* (Vol. III)

Second Story Sunlight—*1960—A.M. sunlight . . . 2 figures—white haired Gothic and elderly and "Toots"—"good Toots, alert but not obstreperous lamb in wolf's clothing" the painter quoted.* (Vol. III)

A Woman in the Sun—*1961—E.H. called her "A wise tramp." Begun cold, very early Oct. 1. Tragic figure of small woman, blond straight brown hair, grabs cigarette before shimmy skirt—brightest note at R. seen off stage, on curtain of window off stage right easts [sic]. Cigarette and sad face of woman unlit.* (Vol. III)

Intermission *painted in N.Y. Studio in March & April 1963. E.H. says she is "Nora.". . . Nora, with strong long hands. She is not the kind to slip feet out of long reasonably high heeled pumps. E. says Nora is on the way of becoming an "egghead." An efficient secretary or prize chatelaine of big house.* (Vol. III)

Conference at Night

1949. Oil on canvas, 27¾ × 40"
Courtesy Wichita Art Museum, Kansas
The Roland P. Murdock Collection

After his marriage to Jo, Edward used his wife as a model for the women in his paintings, being careful to change her face and hair to reflect a specific type. This painting is significant for the way it characterizes the woman as an equal to the two men. During World War II, women assumed important roles in business and industry, and this painting indicates a new basis for male/female interaction that was soon ended after the war by government propaganda aimed at popularizing the traditional female roles of homemaker, wife, and mother.

It is possible to write these references off as an innocent game played by a childless couple. But it should also be pointed out that each painting is an abstraction from life, and that many of the works created a disturbing void that affected even the Hoppers. One could try to make the Nora of *Intermission* (1963) a modern-day counterpart to Ibsen's famous Nora, but the woman in the painting could just as easily be a secretary. The lack of specific information about these people is essential to the art and helps to accentuate the mystery of the commonplace.

Hopper's works depend on ellipses, on the missing parts of a narrative, and on the presence of a viewer who is assumed within the fictive realm of the painting and made a reality by the actual people who look at the work of art. These people take note of the absence of a storyline and then face an ambiguous situation. They do not provide the narrative for the picture so much as note the presences and absences on which this art is premised. In Hopper's work the assumed viewer is analogous to a camera in a film: the unseen but essential *modus operandi* of the work of art. The camera analogy is important, for it enabled Hopper to be intimate and distant, to show glimpses of people's everyday lives without seeming to invade their privacy. Frequently the people spied upon are types rather than individuals, and thus the act of looking is made abstract; it becomes more a phenomenon of the modern world rather than an individual's voyeuristic fantasy, although at times Hopper does succumb to the latter. His paintings, watercolors, and prints maneuver us so that our passive looking becomes a means for acting out the alienation of modern life. The observer then becomes an actor, the painting a script, and the play a reading of the script by the actor/viewer.

Although one cannot provide a specific narrative for an individual work, one can look at earlier pieces made in the French and American traditions to which this artist attaches himself and see how he has reoriented these images. He pares away elements of traditional art to establish a significant ellipsis which creates a new, alienated vantage point indicative of the twentieth-century point of view.

Intermission

1963. Oil on canvas, 40 × 60"
Private collection

The woman here appears to be both familiar and anonymous. She could be a suburban housewife, a corporate executive, or a maid. Hopper is frequently concerned with the fact that people in the modern world can look like distinct individuals without revealing any clues as to their vocation or status.

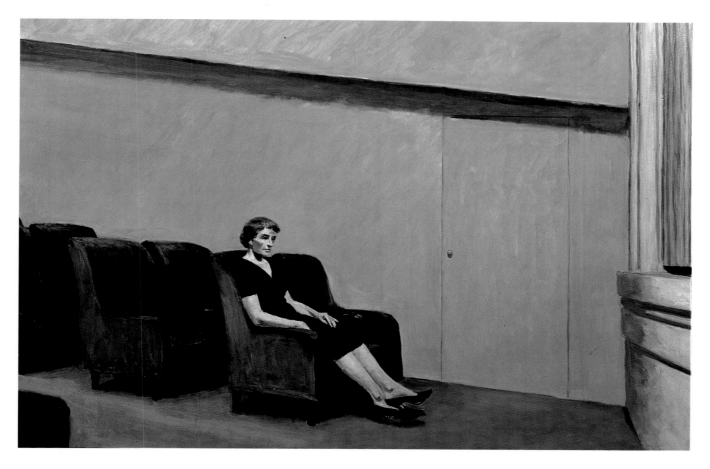

Intermission

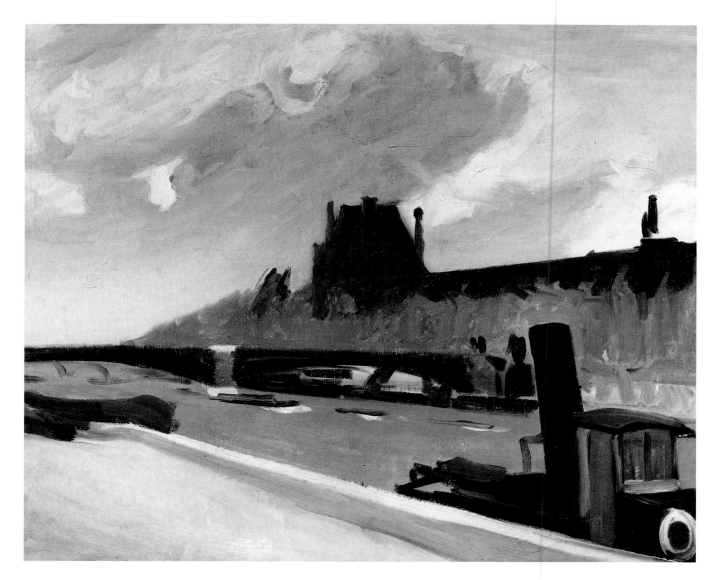

The Louvre in a Thunder Storm

II. Early Development:
Paris and New York

I

N FEBRUARY 1935, Edward Hopper wrote a letter to Nathaniel Pousette-Dart, editor of *The Art of Today*, which contained the following assertion:

In every artist's development the germ of the later work is always found in the earlier. The nucleus around which the artist's intellect builds his work is himself; the central ego, personality, or whatever it may be called, and this changes little from birth to death. What he was once, he always is, with slight modification. Changing fashion in methods or subject matter alters him little or not at all.

In his letter to Pousette-Dart, Hopper was not merely making a felicitous statement; he was reflecting on a truth about his development as an artist which can be understood once his early paintings of Paris are examined. As early as 1920 he recognized the significance of these paintings, and he chose them over his more recent pictures of Gloucester, Massachusetts, and Ogunquit and Monhegan Island, Maine, for his first one-person show at the Whitney Studio Club. These pictures had been made over a decade earlier, and they represented a recapitulation of Impressionism and American Tonalism. Seen in terms of Hopper's overall development, however, these early paintings contain clues to a structural polarity between nature and culture that he would examine throughout his life, and they also indicate the importance light would play in his future work. The use of light became so pervasive and demanding that he once admitted to Lloyd Goodrich, "Maybe I am not very human. What I wanted to do was to paint sunlight on the side of a house." Hopper, the realist, who distances himself from a scene to such an extent that light seems to play an even more important role than people, architecture, and nature, nonetheless is obsessive about the conflicts among culture, industrialization, and nature. Given his continued assertion throughout his life that "every art is an expression of the subconscious," it appears that these conflicts sublimated his own mixed feelings about established culture, the inexorable force of industrialization, the irrepressible quality of nature, and his rightful place in

The Louvre in a Thunder Storm

1909. Oil on canvas, 23 × 28¾"
Whitney Museum of American Art, New York City
Josephine N. Hopper Bequest
70.1223

In his early paintings, Hopper manages to retain a steadfast realism that refuses to be impressed by the greatest of the French monuments. In this painting the Louvre is made to symbolize a bastion of culture that suffers the onslaught of rain and also industrialization, as evidenced by the barge in the foreground.

the modern world. In these early paintings of Paris, art is symbolized by an elevated Second Empire or Gothic building; industrialization by roads, barges, tour boats, trains, and anonymous workers viewed at eye level; and nature is evident in the clumps of undifferentiated shrubbery and trees that force their way into the polarity between art and industrialization. This conflict suggests that Hopper, then a provincial American in Paris, was trying to work out an understanding of the rightful roles for art which seemed to him to be primarily European, for industrialization which he must have connected with the United States, and for nature which had been an important theme in nineteenth-century American and European painting.

When Edward Hopper first left New York for Paris in October 1906, he took with him attitudes promoted by Robert Henri in his classes at the New York School. Henri was a romantic figure and a great teacher. Hopper later admitted that most of Henri's energies went into his classes rather than his art, and that his spontaneous portraits of immigrants and lively characters hardly measured up to "the art spirit" that he later extolled as the title of a book containing his lecture notes and correspondence with students. The son of a shadowy adventurer who had fled a Nebraska gunfight, Henri knew something of the American West and its disregard for traditional rules of conduct. Throughout his life Henri maintained a healthy disdain for traditional limits imposed on the fine arts. He cared little for Greek statues and Renaissance paintings, though he did love seventeenth-century Dutch and Spanish painting because they seemed to be in close touch with the lives of ordinary people. When he came to the Philadelphia Academy, Henri studied with Thomas Anshutz, the student of the great uncompromising Realist Thomas Eakins, who dared to break with Victorian conventions by having men and women art students study naked male models. Influenced by French academic painting, Eakins found its American counterpart in the Colonial Revival style, which he helped to create. His interest in the American Colonial period encouraged him to make his realism democratic, and it also helped him to become self-conscious about his identity as an American painter. Anshutz, Eakins's heir and protégé, was the creator of an important and unsentimental painting of steelworkers at lunchtime, and Anshutz confirmed in Henri the necessity to record the raw vitality of the modern-day world. To Anshutz's teachings, Henri added the paean of joy and life that pervades the writings of the poet Walt Whitman, who was also concerned with the ways American democracy encouraged individuality. Henri, then, was a beneficiary of the twin ideas of realism and democracy, concepts of vital importance to the art of Eakins, Anshutz, and Whitman. And this sensibility guided Henri in his European studies and encouraged him to regard Ma-

Robert Henri
Eva Green

1907. Oil on canvas, 24⅛ × 20¼"
Courtesy Wichita Art Museum, Kansas
The Roland P. Murdock Collection

In his paintings, Robert Henri exploits Walt Whitman's zeal for America and seeks to capture the vitality and diversity of people in its cities. The art looks back to seventeenth-century Dutch and Spanish painting and to mid-nineteenth-century French art. It is inherently democratic and revolutionary in its social aims even if its artistic means belong to a long tradition.

net and Degas as artists who were attempting to rid their work of dead rhetorical devices and remain true to their own perceptions of the nature of contemporary reality. When he returned from France, Henri maintained his egalitarian approach and befriended a group of illustrators working for the *Philadelphia Press*. This group included William Glackens, George Luks, Everett Shinn, and John Sloan. After Henri left Philadelphia for New York City, these men followed him, and within a few years each of them gave up illustration to paint in a manner that came to be called the Ash Can School. These artists documented the peak period of immigration to the United States, which began in 1890 and continued until World War I, when sixteen million people, mostly Europeans, entered this country. For the most part these immigrants lived in urban centers, and the Ash Can painters recorded both the increase and variety of street life in

Thomas Dewing
Summer

c. 1890. Oil on canvas, 42⅛ × 54¼″
National Museum of American Art,
Smithsonian Institution, Washington, D.C.
Gift of William T. Evans

Thomas Dewing, a Tonalist, created an evocative and dreamlike world. Coming after the settlement of the American West, he viewed nature as intimate, refined, and domesticated by fashionable sylphs. His idealized art represented the norm against which Hopper reacted.

New York City that resulted from the large influx of diverse peoples.

The Ash Can painters' background as illustrators bespeaks an important current in American turn-of-the-century art that contrasts with the art-for-art's-sake attitude of Thomas Dewing, John Henry Twachtman, Dwight Tryon, and Whistler. This emphasis on art as a record of contemporary events also contrasts with the aristocratic attitudes of John Singer Sargent, who used seventeenth-century European royal portraits by Anthony van Dyck and eighteenth-century English portraits as models for his paintings of the rich in both Europe and America. The pragmatic approach of Henri and his cadre of illustrators-turned-artists also differed from the art of Sargent's peer William Merritt Chase, an art that focused on refined French-inspired landscapes painted out-of-doors as well as on the artist's studio with its exotic bibelots collected from trips abroad. Sargent's and Chase's art thus represents a carefully cultivated world that differs from the reportorial stance of Henri and his Philadelphia associates.

Since Hopper had been a student at the Chase School (later named the New York School of Art) from 1900 to 1906, and had studied illustration before attending the fine arts classes that Henri, Miller, and Chase taught, he was fully apprised of the differences and possible interconnections among illustration, Henri's democratic approach, and Chase's more

William Merritt Chase
In the Studio

c. 1884. Oil on canvas, 39 × 22"
Reynolda House Museum of American Art,
Winston-Salem, North Carolina
Original purchase fund from the
Mary Reynolds Babcock Foundation, the
Z. Smith Reynolds Foundation, and the
Arca Foundation

William Merritt Chase, one of Hopper's teachers, was important for his understanding of Impressionism and his reliance on color as a way of rendering light. Though Chase's Impressionism may have been regarded as advanced in the United States, it was hardly innovative when compared to the developments of the French Impressionists a quarter of a century before. Chase's world is cultivated and refined; he presents the artist's studio as a refuge from the outside world, a place for extremely civilized pleasures, and precious objects lovingly collected on special European tours.

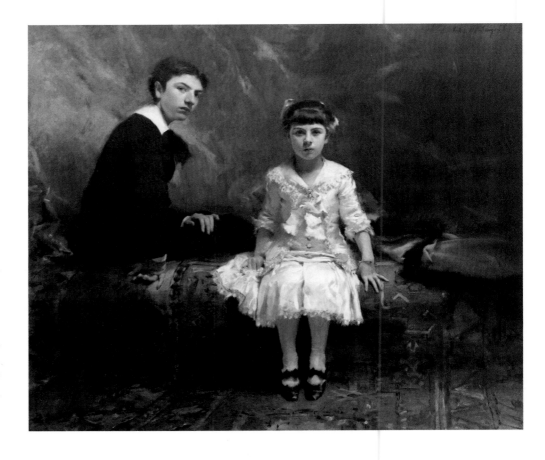

John Singer Sargent
The Pailleron Children

1881. Oil on canvas, 60 × 60″
Des Moines Art Center
Edith M. Usry bequest fund in memory of
her parents, Mr. and Mrs. George Franklin
Usry, and additional funds from Dr. and
Mrs. Peder T. Madsen, and the Anna
K. Meredith Endowment Fund, 1976

*Following in the tradition of Van Dyck,
Sargent aggrandized his rich clients and
made them into contemporary nobility. A
remarkable portraitist, he complemented
his sitters and at times penetrated their
façade to reveal their strengths and weak-
nesses.*

Dome

1906–7. Conté, wash, charcoal,
and pencil on paper, 21⅜ × 9⅞″
Whitney Museum of American Art, New York City
Josephine N. Hopper Bequest
70.1434

*Dome attests to Hopper's great love of
architecture. He found buildings to be
powerful symbols of humanity, and he es-
tablished a manner of looking at them as
personalities that manifested values of
other times and places.*

refined art that appealed to the upper classes. In his student works Hop-
per attempted to emulate contemporary illustration, and he also tried out
Henri's Dutch- and French-inspired egalitarian portraits, as well as
Chase's genteel tradition. During this time he made studies of French aca-
demic and avant-garde artists alike, and seems not to have differentiated,
for example, among Henri Regnault's *Salomé*, Manet's *The Fifer*, and Jean-
François Millet's *Man with a Hoe*. All were available for study, and all ap-
pear to have been equally interesting to an artist who was learning about
technique and looking for a suitable subject and an appropriate means of
conceiving it.

Only when Hopper left New York City for Paris did he begin to come
to terms with a subject that would serve as a basis for his future work. At
first he oscillated between illustration and the fine arts as is evident in his
early studies. He made watercolors of various French characters that bor-
der on caricature, but he also created drawings that reveal his studies of
Charles Méryon, Manet, and Jean-Louis Forain. The drawings *Dome* and
The Railroad indicate his interest in these particular French artists: *Dome*
demonstrates an appreciation of Méryon, and *The Railroad* an under-
standing of Manet and Forain. In *Dome* Hopper is concerned with the
mysteriousness of ancient buildings, which for him connote the lasting

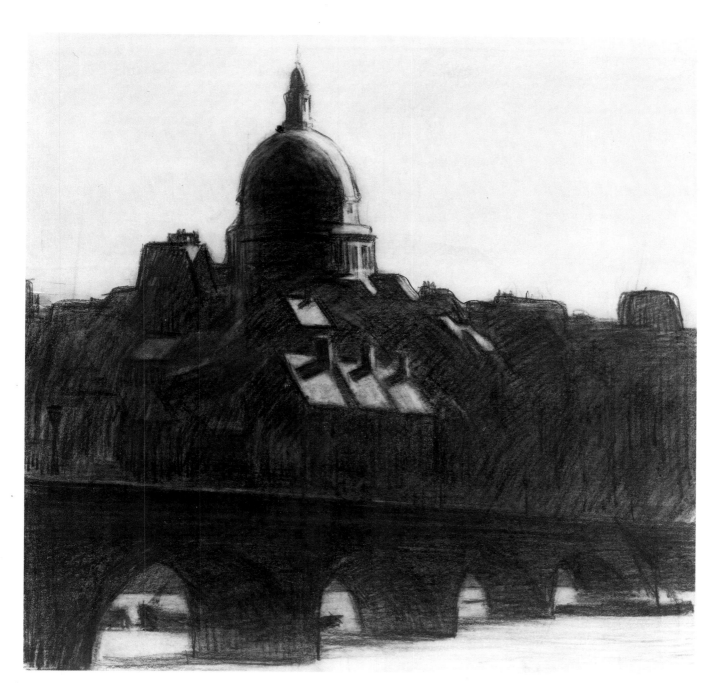

Dome

The Railroad

Charles Méryon
*Etchings of Paris (L'Abside de Notre-
Dame de Paris)*

1854. Etching, 6½ × 11¾"
The Cleveland Museum of Art
Gift of Leonard C. Hanna, Jr.

*Méryon's etchings were profoundly im-
portant to Hopper for their mysteriousness
and for their beautifully rendered archi-
tectural subjects.*

values of a traditional culture, but he distances these old values from him-
self by locating his vantage point somewhere across the bridge. Far more
familiar and accessible to the artist is *The Railroad*, which is also closer to the
art of Henri and Manet. With a few changes in costume, particularly the
soldier in the foreground, this scene could have taken place in any mod-
ern European nation or in the United States. *Dome* and *The Railroad* pro-
vide views of the old and new Europe; seen together they emphasize
possible conflicts between traditional culture and modern life.

These two views are united in a number of Hopper's paintings of Par-
is. In *The Louvre in a Thunder Storm* (1909) the museum is situated high in
the middle distance—it is a fortress protected by shrubbery and trees—
while the foreground is given over to a contemporary barge. In *Le Quai des
Grands Augustins* (1909) the prominent point of view is from a road, which
leads to a group of boats and a bridge. To the right a group of high build-
ings is accessible only through the dark, steep stairway in the right fore-
ground. One might argue that Hopper painted only what he saw and that
his views do not differ dramatically from those scenes popular with other
American and foreign artists then working in Paris. But in these early
works it is apparent that Hopper has already established a polarity be-
tween culture and industrialization.

Hopper's *Le Pont Royal* (1909) anticipates *House by the Railroad* (1925)
by fifteen years. The latter painting is important for its presentation of a
new psychological understanding of the differences between old world
and twentieth-century culture. In the former work the French building is
cut off from viewers by a retaining wall and bridge that extend across the
entire painting. In the latter work the European building is replaced by a
Victorian mansion with a similar French-inspired Mansard roof. The Vic-

The Railroad

1906–7 or 1909. Conté, charcoal,
and wash with touches of white
on paper, 17¾ × 14⅞"
Whitney Museum of American Art, New York City
Josephine N. Hopper Bequest
70.1437

*The Railroad occupies a midpoint be-
tween illustration and fine art. This draw-
ing is important for its emphasis on
directly perceived experience and for its
emphasis on the railroad, a subject Hop-
per would frequently return to.*

Le Quai des Grands Augustins

torian mansion is significantly cut off from the viewer by a railroad track that spans the width of the painting: the retaining wall that lends an air of protectiveness to the French building becomes in *House by the Railroad* a disjunctive railway track that is an occasion for unrest. The railroad track indicates continuity, a spanning of a transportation line across a broad area of terrain regardless of its former use, and the painting becomes a testament to obsolescence and the inexorable force of progress. The base of the house is cut off from view, and thus it appears to float mysteriously above the observer who is located on the opposite side of the rusting railroad track and at eye level with it. In this painting the Second Empire house, which might have connoted the transferal of lasting European cultural values to American soil, is viewed as fragile, preposterous, and totally unconnected to the landscape and to the industrial forces tying together twentieth-century America. Its entrance is shrouded in shadow, and its windows admit no signs of life.

An equally interesting comparison to the one between these early Paris paintings and Hopper's later works can be made between *Le Pont Royal* with *Queensborough Bridge* (1913), the latter painting created only a few years after Hopper returned to the United States. In *Le Pont Royal* the bridge provides an important link even though it does not upset the balance between buildings intended for habitation and bridges used for the transportation of people and goods. In *Queensborough Bridge,* however, the balance is upset, and the clapboard house looks pathetic in relation to the bridge. In the later painting human values have obviously been upset and made incidental; the indomitable force of new technological monuments prevails. The conflict between the unmitigated power of the bridge and the isolated and dwarfed nineteenth-century clapboard house parallels battles between the great trusts and individual companies that had become the subject for the muckrakers Ida M. Tarbell, Lincoln Steffens, David Graham Phillips, and Upton Sinclair and a rallying point for the reformers William Jennings Bryan, Robert M. La Follette, Theodore Roosevelt, and Woodrow Wilson. In 1912, a year before Hopper created this painting, Roosevelt and Wilson were arguing over the best way to handle trusts. Roosevelt believed that regulating monopolies was more feasible than restoring competition. The majority of the people, however, were altogether afraid of trusts, and so they championed Wilson for the presidency because he wanted "the pigmy to have a chance to come out." From *Queensborough Bridge* one can surmise that Hopper was sympathetic to Wilson's ideas and in favor of restoring a sense of the balance and proportion that the new president viewed as inherent in laissez-faire capitalism.

The conflict between trusts and small entrepreneurs, between big business that encouraged sprawling cities and the isolated individual, was

Le Quai des Grands Augustins

1909. Oil on canvas, 23½ × 28½"
Whitney Museum of American Art, New York City
Josephine N. Hopper Bequest
70.1173

Hopper's scenes of Paris are remarkable for their emphasis on both the ordinary and unique aspects of the city. He makes barges, roads, bridges, and stairways as important as the grand old buildings for which Paris is famous.

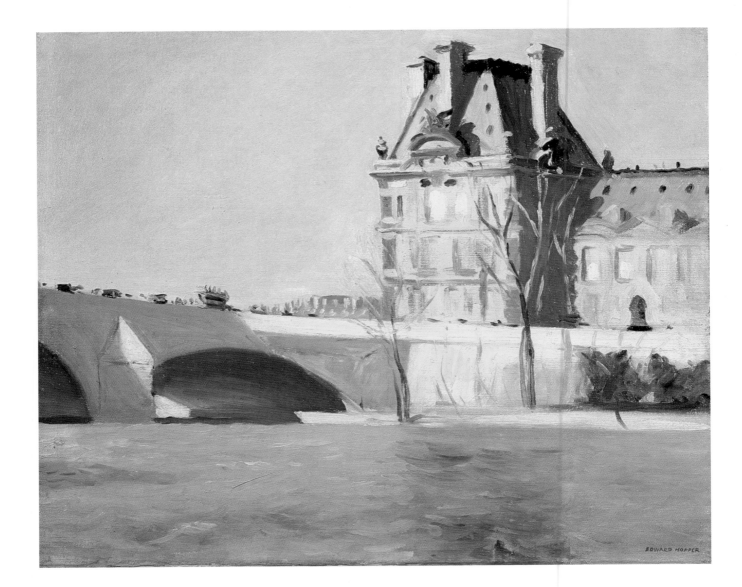

Le Pont Royal

1909. Oil on canvas, 23¼ × 28½"
Whitney Museum of American Art, New York City
Josephine N. Hopper Bequest
70.1175

A prototype for House by the Railroad, Le Pont Royal *presents alliances between culture and commerce in Europe that contrast with the enormous gulf between the two in the United States.*

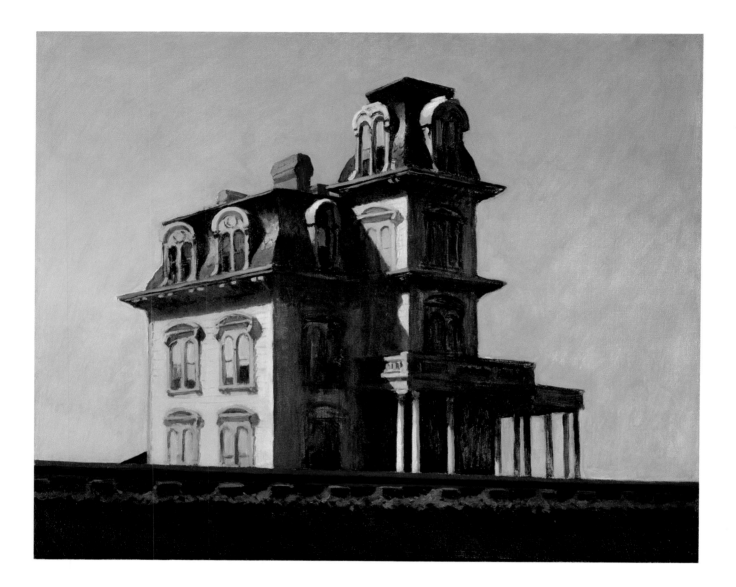

House by the Railroad

1925. Oil on canvas, 24 × 29″
Collection, The Museum of Modern Art,
New York City
Given anonymously

The railroad tracks cutting across the canvas masks the horizon line and causes the old Victorian house to look as if it is looming uneasily above the tracks. This picture dramatizes tensions between big business and traditional culture.

to be a major theme in Hopper's art. This theme has a source in Progressivism, but it goes beyond the political in Hopper's mature work to become symbolic of the state of the twentieth-century individual who may hold dear the nineteenth-century values symbolized by a clapboard house in *Queensborough Bridge*, an individual, though, who is isolated and alienated and who cannot be regarded as merely quaint. The quaintness of the subject of *Queensborough Bridge* defeats the picture's impact and makes it more a forerunner than a clear example of Hopper's mature work. In addition, the soft grays and veiled atmospheric effects that were so adequate to the refined sensibilities of Tonalist painting and to depictions of intimate landscapes are at odds with the subject of this picture. The lack of agreement between the nostalgic style of the painting and its contemporary subject matter may have encouraged Hopper to drop mainline Impressionism and its close relation Tonalism and find a more rigorous means for manifesting his ideas.

Queensborough Bridge was created a year after the Italian Futurists showed their new works in Paris at the Bernheim-Jeune Galleries and the same year that the French Dadaist Marcel Duchamp shocked Americans at the New York Armory Show with his Futurist-related painting entitled *Nude Descending a Staircase*. Hopper's work appears to be aware of the rhetoric of Futurism, which aimed at a renewal of art and life through the speed and force of the automobile, and most important, it appears to mount a critique of Futurism's optimism by placing a great riveted steel bridge alongside an isolated clapboard house to show that progress has its price.

Although Hopper later told Brian O'Doherty that he worked in Paris in a Pointillist style, his art in the first decade of the century is different from *Queensborough Bridge* in being midway between Impressionism and Tonalism. It lacks the texture of much Impressionist painting and also the overall grays and the twilight of Tonalism. Hopper's style in this period combines flat planes of subdued color with their complements to approximate the effects of sunlight and shadow. This technique becomes a basis for Hopper's later style, which disciplines his early brushwork and at the same time creates the effects of bright harsh light by accenting clear broad passages of color with complementary hues.

In a work such as *Riverboat* (1909) it is important to note how Hopper impresses on the viewer a nonjudgmental point of view. In this painting the building and retaining wall are blurred while the tour boat is seen in relative focus to communicate the casual glance of a tourist who is more concerned with the boat than with the view of the city that is presented. Hopper affirms his own vantage point in this painting and underscores the innate realism that becomes an important trademark of his art. Even

Queensborough Bridge

1913. Oil on canvas, 25½ × 37½"
Whitney Museum of American Art, New York City
Josephine N. Hopper Bequest
70.1184

Although the Tonalist style is out of character with the harsh reality of the scene, this painting is important to Hopper's overall development since it presents a nineteenth-century clapboard house dwarfed by the Queensborough Bridge and thus strikingly dramatizes Hopper's desire to depict the inexorable force of industrialization and the individual's consequent loss of power.

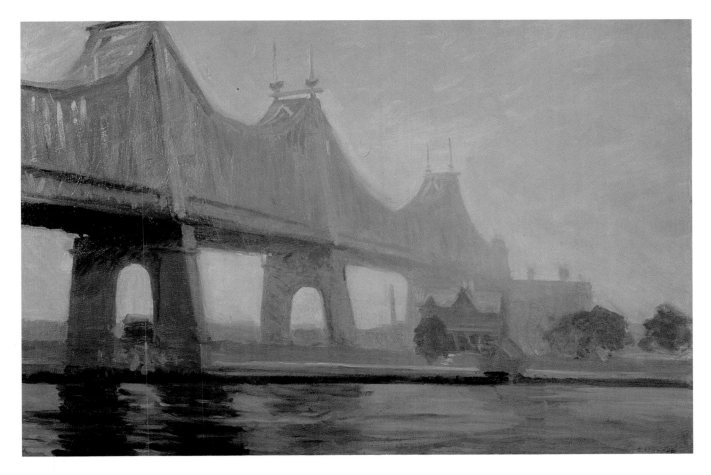

Queensborough Bridge

in this early painting, created at the time he is most involved with Impressionism, Hopper refuses to pretend to an insider's point of view of Paris and instead affirms his role as an outsider. His distance is augmented by an egalitarian outlook that provides him an opportunity to look at well-known sites from a new vantage point and to accord boat landings, barges, bridges, canal locks, streets, and workhouses as special a place as those tourist sites listed in Baedeker's guidebooks.

Later in his life Hopper reflected that it took almost a decade for him to get over Paris. A more realistic assessment is that it took Hopper over a decade to recognize that the Paris paintings contained important ideas that could be translated into an American idiom. His brief time in Paris is surprising for the isolation it provided him and for the opportunity he took to examine his own mixed feelings about old-world culture and industrialization. Unlike many Americans abroad, he did not turn to new directions so much as use his time in France to distance himself from the New York School of Art and to find a means to turn both Chase's and Henri's approaches to advantage. He reframed the controversy between the art-for-art's-sake adherents and the burgeoning Ash Can School by finding European architectural equivalents for aristocratic and democratic values. A man who could apparently see clearly both sides of an argument, Hopper evolved in Paris a subject matter that held in suspension the controversy and provided a dynamic for future developments.

This symbolic rephrasing of the American cultural controversy between the new and the old—between illustration and the fine arts: industrialization or modernization and old-world culture, and democracy and elitism—became a focus for Hopper's Parisian paintings, and this redefinition of basic cultural conflicts enabled him to make a sudden leap toward maturity without having to feel the need to investigate the new styles of Fauvism and Cubism, which were then being developed in France. But when Hopper returned to New York, the conflict seemed less obvious, and he floundered for almost a decade until he began in the early twenties—partially as a result of the first one-man exhibition of his Paris paintings at the Whitney Studio Club—to see how he had already laid the basis for an important course of development. In the teens he tried two notable points of view: the first was a brief recapitulation of French Symbolist art in the important but problematic *Soir Bleu* (1914), and the second was a thoroughgoing analysis of advances made by the Ash Can painter John Sloan, who seemed successful in understanding how ordinary people live in modern cities.

Probably Hopper's most ambitious work in the second decade is *Soir Bleu*, a painting that makes claim to the insider's view of Paris that Hopper refrained from assuming when he was in France. In this work Hopper

Riverboat

1909. Oil on canvas, 28 × 48"
Whitney Museum of American Art, New York City
Josephine N. Hopper Bequest
70.1190

The viewer of this scene is allowed to focus on the tour boat and is given only a passing glance at the buildings, which are shown slightly out of focus. In this manner Hopper approximates the seeming casualness of nineteenth-century Impressionism, which memorialized social and economic change as well as the fleetingness of life.

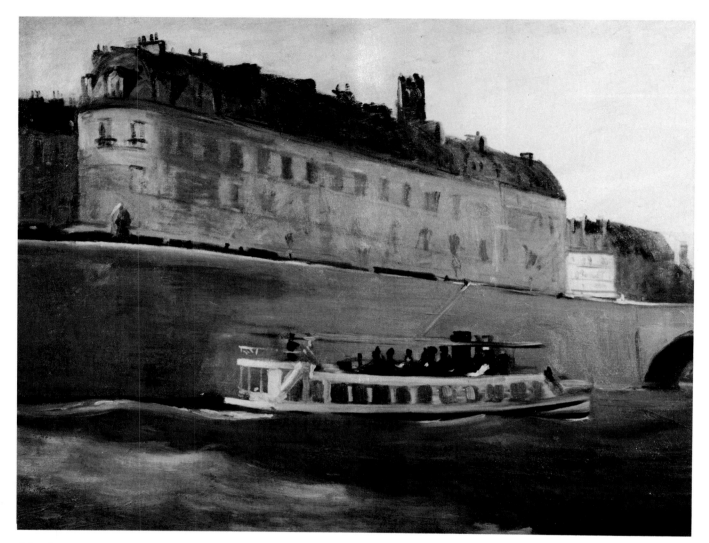

Riverboat

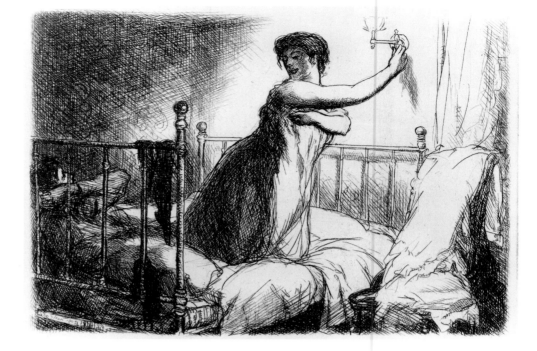

John Sloan
Turning Out the Light
(from the New York City Life
series)

1905. Etching, 5 × 7"
Delaware Art Museum
Gift of Mrs. John Sloan

*Sloan's etchings as well as his paintings
served as important prototypes for Hop-
per's art.* Turning Out the Light *can be
considered a source for Hopper's* Eve-
ning Wind.

tries to picture French nightlife. Though he is giving image to the solitary
calm that can pervade any café and fill it with melancholy, his figures seem
stiff and uncomfortable. They look like actors who are posing rather than
people who are participating in a real event and afflicted with ennui and
desolation. The figure on the left resembles one of Hopper's illustrations
of French types that he had made several years earlier in Paris, and it bor-
ders on caricature. Only the clown seems comfortable in this stage set. In
comparison to the night scenes of Degas, Manet, Shinn, and Sloan, Hop-
per's *Soir Bleu* looks empty, heavy-handed, and stilted. Rather than con-
vincingly symbolize the ennui of modern life like Picasso in his Blue
Period, Hopper tries to picture individuals suffering this modern malaise.
The result is a picture that is unfocused and lacking in the subtle and pro-
found drama of the uneventful, everyday lives of ordinary people, which
is a hallmark of Hopper's mature art.

Soir Bleu is his single excursion into French Symbolism: it represents
an attempt to give form to the subtle melancholy of modern life and to
find an abstract equivalent for a specific feeling in terms of the color blue.
The French title refers to the artist's time in France and to his knowledge
of the French language, which he respected and read throughout his life.

One might find the title and subject matter of this painting pretentious,
unless one recognizes that it was created in 1914, the year World War I be-
gan in Europe. No doubt the coincidences between the advent of war and

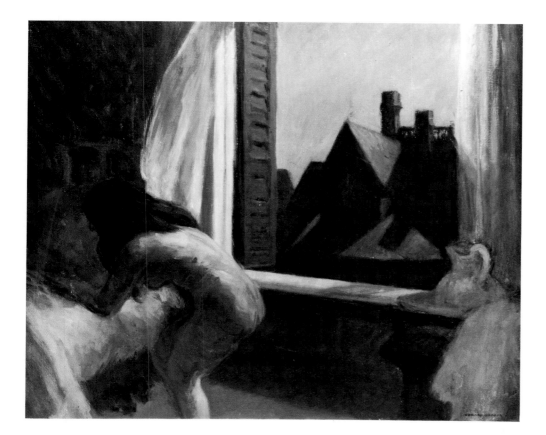

Moonlight Interior

1921–23. Oil on canvas, 24 × 29″
Private collection

In the 1920s Hopper began to recognize the poetry of the everyday world as his true subject.

the French title of the painting were more than happenstance. The size of the picture—three feet by six feet—the largest painting made by Hopper up to that point—and the fact that it was created a year after the New York Armory Show, suggest that he was attempting to give form to the passing of an era in *Soir Bleu.* Unfortunately, the painting did not measure up to his real concern for France, and the lack of conviction of the finished picture may have been a major factor in convincing him not to attempt to paint groups of people.

Throughout the rest of the second decade, Hopper worked out his identity as an American artist, and in the teens and early twenties he chose John Sloan's art to emulate and to critique. Hopper's recognition of the importance of an American identity may have been stimulated by the war and by the fact that Europe seemed to be caught up in its own turmoil, but his connections with his own country are also evident in the outsider point of view of his Parisian paintings, his early scenes of Gloucester, and his *Queensborough Bridge* mentioned earlier. In retrospect these works separate Hopper from European art movements and indicate the importance that the United States had for his art. He was fascinated with the tensions in his own country between stasis and progress. In the second decade of the century Hopper began to consider seriously Henri's teachings about

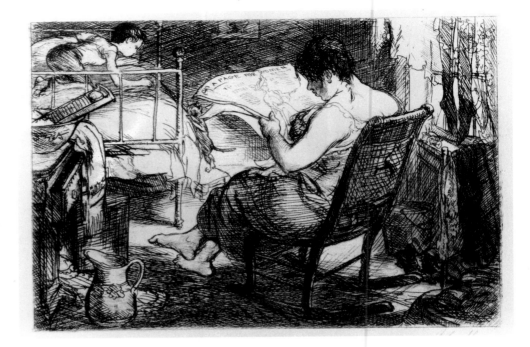

John Sloan
The Woman's Page
(from the New York City Life series)

1905. Etching, 5 × 7″
Delaware Art Museum, Wilmington
Gift of Mrs. John Sloan

The Woman's Page by Sloan can be regarded as a source for Hopper's Room in Brooklyn. *While Sloan is interested in showing twentieth-century families living closely together within the confines of tenements, Hopper is concerned with the isolation and loss of individuality that frequently attend life in a big city.*

Room in Brooklyn

1932. Oil on canvas, 29 × 34″
Courtesy Museum of Fine Arts, Boston
Charles Henry Hayden Fund

Hopper takes a traditional image of a woman who is sewing, an image popular in eighteenth- and nineteenth-century art, and gives it a special contemporary feeling when he turns the woman away from the viewer and makes her as anonymous as the mass of undifferentiated Brooklyn tenements outside the window.

the democracy of art, the ready availability of significant subject matter in the United States, and the irrepressibility of the art spirit in the modern world and to ground them in his own distinct style. He found that John Sloan, Henri's disciple, had already begun to solve the problem of turning illustration into art, even though Sloan was only partially successful in his efforts.

In a 1927 article on Sloan for *The Arts,* Hopper praises the older artist for his directness and his ability to avoid becoming entangled by theory:

Sloan is one of those rarely fortunate artists who distort unconsciously and to the point and without obvious process. His is the distortion that looks like truth and not that which looks like distortion. . . . His drawing rarely has dead spots and his figures have the unaffected gestures of the human animal when unobserved. The object drawn is seen first before one becomes conscious of its design as the linear structure that holds the various units together.

He also points out that time has altered Sloan's images and made them less radical than they once were:

Time and the violence of modern technical innovations have tempered what was once felt to be a brutal naturalism in these things of Sloan's and a more accustomed vision could now place these works with those of Teniers, Brueghel, and their contemporaries.

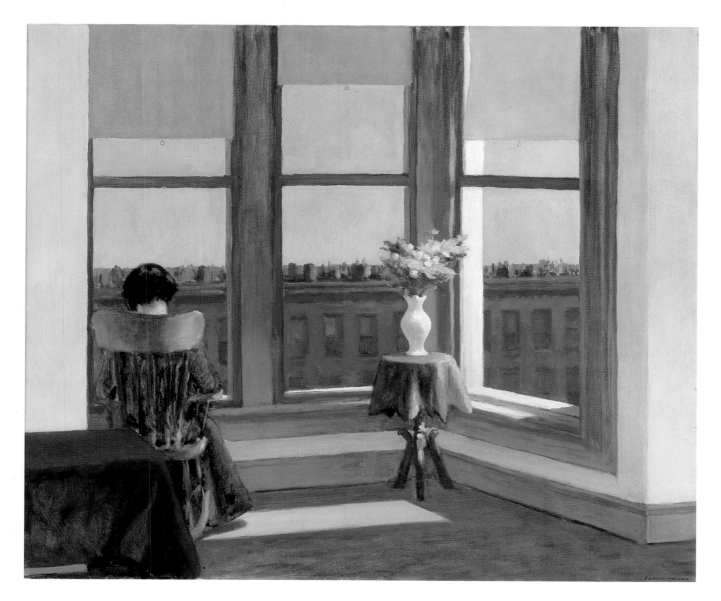

Room in Brooklyn

[Rocky Shore and Sea]

1916–19. Oil on wood, 11⅞ × 16″
Whitney Museum of American Art, New York City
Josephine N. Hopper Bequest
70.1290

*In the teens of this century Hopper worked
as an illustrator while grappling to find a
suitable subject matter and style. His oil
sketches of Monhegan Island, Maine, in-
dicate an interest in John Sloan, an artist
who painted similar subjects. However the
broad manner of working with both brush
and palette knife constituted a short-lived
phase for Hopper, who preferred in his
mature art to paint transparent darks and
impastoed light areas.*

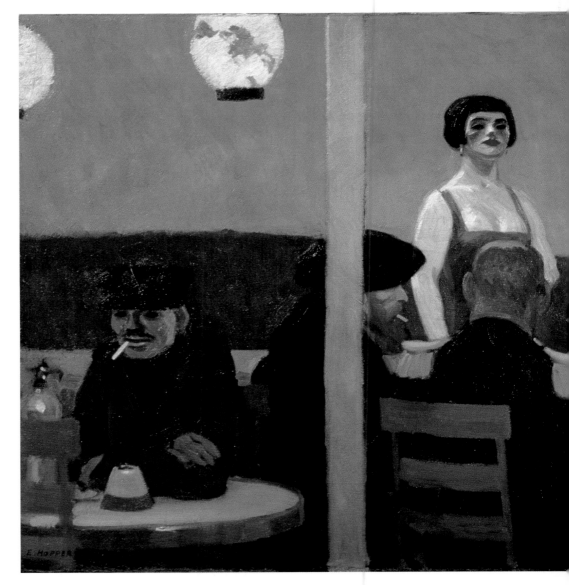

"Can it be," Hopper asks, "that the frankness of Brueghel is not now so strongly felt because one has been so long familiar with his idiom?" The rhetorical question indicates a route of development for Hopper's own art: a critiquing and updating of the work of Sloan and the Ash Can painters that he characterizes as "the first really vital movement in the development of a national art that this country has yet known."

A cursory glance at Sloan's work provides a surprising number of themes that are crucial to Hopper's art. Sloan pictured ordinary people living in tenements, solitary individuals viewed from other apartments, and persons staring out of city windows. He also dealt with popular theaters, restaurants, and undistinguished buildings, and he made studies of

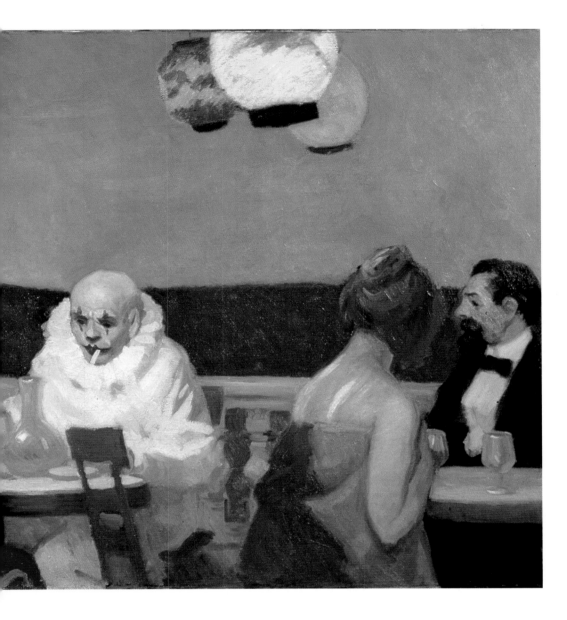

Maine and Massachusetts seascapes that were important for Hopper's heavy-handed studies of Monhegan Island. Sloan's *Turning Out the Light* (1905) from his etching series New York City Life appears to be a source for Hopper's painting *Moonlight Interior* (1921–23) and also a distant ancestor for the figure in *Evening Wind* (1921). Similarly, *The Woman's Page* (1905), also from the New York City Life series, a "peeper's view" of another tenement according to Sloan, provided a basis for a number of Hopper's works that contained the glimpses of everyday life available to city dwellers. In such works as *Apartment Houses* (1923), *Office at Night* (1940), and *Office in a Small City* (1953), Hopper plays with the closeness and the distance affecting modern city dwellers who regularly witness intimate

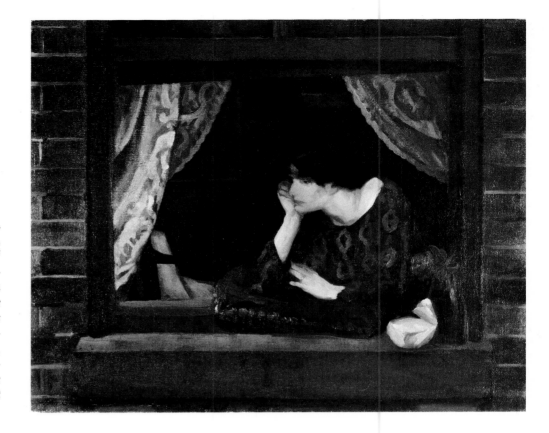

John Sloan
A Window on the Street

1912. Oil on canvas, 26 × 32″
Bowdoin College Museum of Art,
Brunswick, Maine

Sloan's painting belongs to a grand tradition dating back to the Renaissance, when women leaned over balustrades that were draped with oriental carpets. He updates the format without diminishing its elegance and refinement. His painting, however, is subjected to Hopper's unequivocal realism in Eleven A.M., *where a naked, bored girl replaces the elegant woman.*

Eleven A.M.

1926. Oil on canvas, 28⅛ × 36⅛″
Hirshhorn Museum and Sculpture Garden,
Smithsonian Institution, Washington, D.C.
Gift of Joseph H. Hirshhorn Foundation, 1966

A naked girl looks out onto a city street. She could be a prostitute, or she could be an outsider who is not a part of the city's regular daytime schedule. Her idleness is suspect, as is the viewer's presence in this room at 11:00 A.M.

scenes between people who are total strangers. In these works Hopper disciplines the seemingly innocent charm of Sloan's mother in a rocking chair to picture a world in which even the art viewer becomes a voyeur who must confront the fact that looking has become an invasion of privacy and an admission of alienation. In *A Window on the Street* (1912) Sloan makes his subject a Pre-Raphaelite type reminiscent of the Jane Burden portraits painted by Dante Gabriel Rossetti and suggestive of the grand tradition, going back to Renaissance and medieval times, of picturing women leaning over balconies. And Hopper takes this image and strips it of Sloan's gentility: he avoids the Pre-Raphaelite allusion to grandeur, the velvet cushions, and the lace curtains and makes of his more prosaic woman in *Eleven A.M.* (1926) an emblem of the haunting barrenness of modern life. In this painting the girl's identity is unclear: she could be anyone, a wife or mother, even a prostitute, whose daytime activity offers little more excitement than a view out of a tenement. In [*Girl at Sewing Machine*] (c. 1921), he takes a traditional image of domestic felicity—a woman doing handwork beside a hearth—and gives her a sewing machine and a city window. In *Room in Brooklyn* (1932) he emphasizes even more the loss of this genteel domestic tradition when he places a woman in a rocking chair before a window that looks out at hundreds of anonymous tenements.

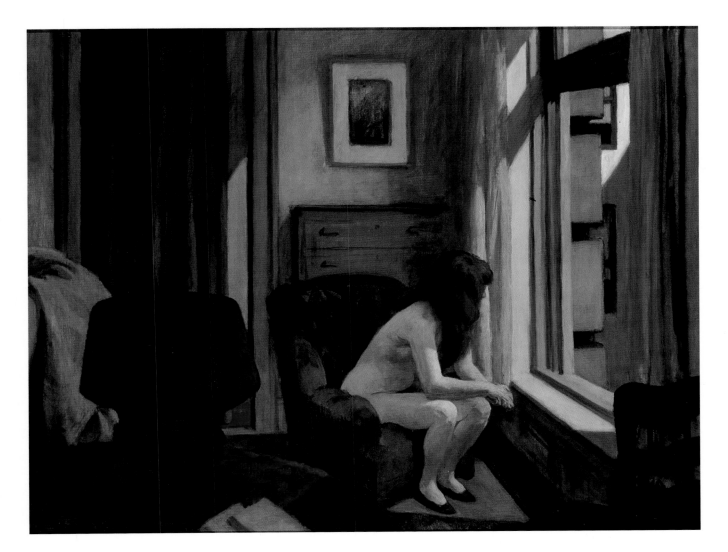

Eleven A.M.

John Sloan
Pigeons

1910. Oil on canvas, 26 × 32"
Courtesy Museum of Fine Arts, Boston
Charles Henry Hayden Fund

Although Pigeons *is a remarkable paint-*
ing of the modern American city, Sloan,
unlike Hopper, is not content to paint a
straightforward picture of contemporary
reality; he adds an anecdotal reference in
the form of birds, which transforms the
painting into a genre scene and thus miti-
gates the barrenness of the modern city.

[Girl at Sewing Machine]

c. 1921. Oil on canvas, 19 × 18"
Collection Thyssen-Bornemisza

This painting is transitional for Hopper.
It shows the influence of the Ash Can
School on the artist, and it also anticipates
his mature works that focus on isolated
people in the city. The painting is more
concerned with recording an ordinary
contemporary event than with emphasiz-
ing the possible psychological meaning of
that event.

Although individual works by Sloan appear to have been sources for specific paintings by Hopper, it is not possible to claim, for example, that *Isadora Duncan* (1911) is the source for *Girlie Show* (1941), *Carmine Theater* (1912) the point of departure for *New York Pavements* (1924), *Renganeschi's Saturday Night* (1912) the basis for *New York Restaurant* (c. 1922) and *Chop Suey* (1929); or *Bachelor Girl* (1915) the idea for *Hotel Room* (1931). The two artists are both adhering to the tradition begun by the French Impressionists of picturing ordinary people in modern cities. One might assert with some conviction that Sloan's *Pigeons* (1910) is the basis for Hopper's series of paintings and watercolors of undistinguished buildings making up New York City's skyline even though Hopper differs from Sloan in avoiding ingratiating elements like the pigeons. Hopper makes an image of the modern city that questions its own value, an image that implicitly asks who is looking at it and who deems it a view worthy of contemplation.

Unlike Sloan who fought for the rights of workers to unionize in illustrations for *The Call* and *The Masses*, published between 1910–20, Hopper illustrated periodicals that represented the official voice of major corporations. Among the more important was *Edison Monthly, Hotel Management, The Morse Dry Dock Dial, Profitable Advertising: The Magazine of Publicity, System, The Magazine of Business, Tavern Topics,* and *Wells Fargo Messenger.* Hopper's work as an illustrator was sufficiently profitable for him to live, with some frugality, by working only three days each week. In his art, as opposed to his commercial illustrations, he was interested in the lives of ordinary people, but unlike Sloan he was not concerned with direct political reform. Hopper was much more involved with a new and distinct sensibility characteristic of his own era. He may have sympathized with labor unionizers, but his art indicates that overtly political imagery was of no interest to him. He was concerned with general human values, and he used art as a way to frame the forces at work in the modern world. Although he was interested in Progressive ideas throughout his life and chose to pay homage to the small-time entrepreneur in his paintings of the corner drug store, barber shop, tourist home, and rural gas station and decided not to ennoble in his art the interests of big business, it is apparent that he was a realist in life as in art: he could make a living by illustrating periodicals that glorified big business even though he chose to support opposing forces in his art.

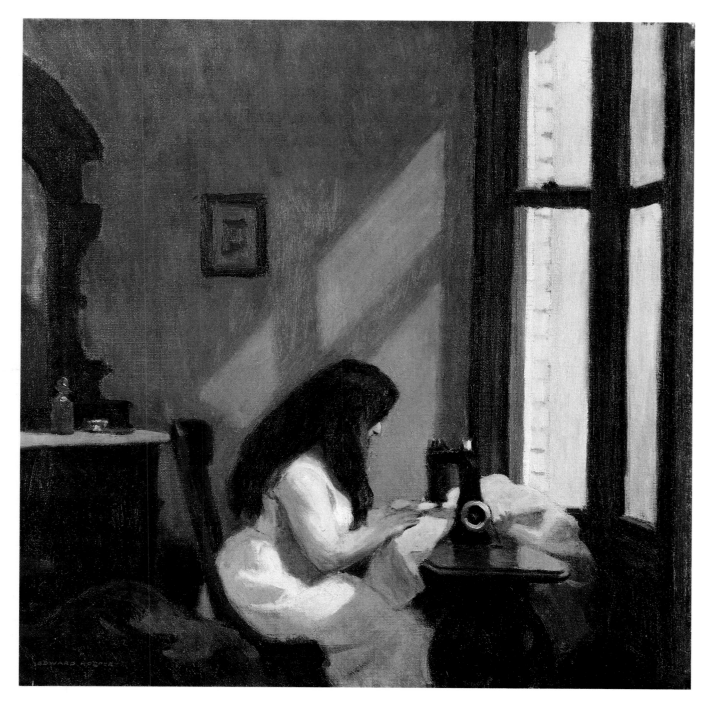

[Girl at Sewing Machine]

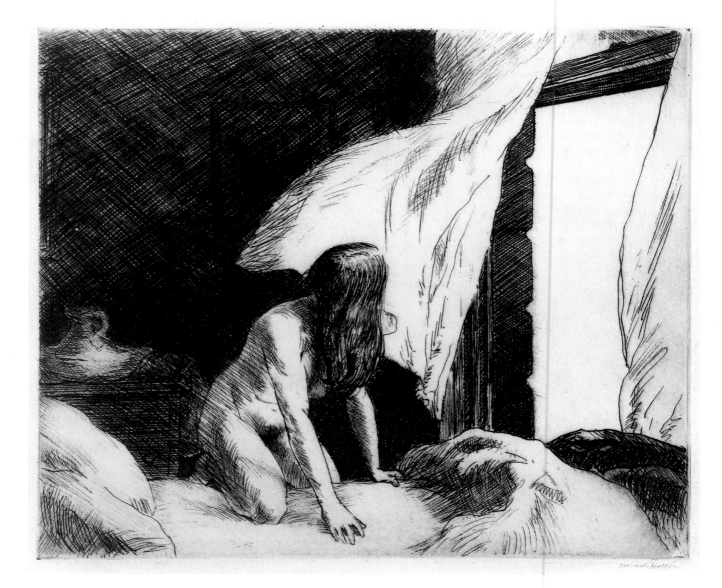

Evening Wind

III. Transition: The Etchings

IN 1915, as he was rethinking his art in light of John Sloan's work, Hopper took up etching, a print medium that differed from lithography and silkscreen in having obvious fine art associations. Etching had been revived in France in 1862 when A. Cadart organized the Société des Aquafortistes, which included artists Félix Bracquemond, Johan Jongkind, Édouard Manet, and Charles Méryon, among others. Etching, like lithography, was capable of recording the delicacy of drawing, but unlike lithographic stones and the steel-faced plates of engraving, which allowed almost unlimited impressions, etched copper and zinc plates could only be used for limited editions, and thus they were not associated with the prosaic uses to which lithographs and engravings were frequently subjected. Etching provided Hopper an opportunity to compensate for his commercial work: it differed radically in aim and effect from the offset lithography that was used for most of his illustrations. Etching also allowed Hopper to suspend questions of color and to focus on light, which was of primary importance to him. However Hopper did not succumb to the preciousness of art-for-art's-sake attitude advocated by many etchers. His years as an illustrator had imbued in him a healthy distrust of any art that was removed from life, as his review of Malcolm Salaman's book *Fine Prints of the Year, 1925* indicates:

As we go through these pages we hear much of the "true etcher's linear conception," etc. Salaman is not the only one who talks foolishness about this etcher's line. As if the etcher's line were different from the line of anybody else! The etcher's line has degenerated into an end in itself and as such has become sweet and sugary beyond belief. God give us a little vinegar! Of course the trailing of the line on copper is as seductive a performance as the loading of luscious paint on canvas. However, "modernism" is combatting the latter aesthetic degeneracy. We have had a long and weary familiarity with these "true etchers" who spend their industrious lives weaving pleasing lines around old doorways, Venetian palaces, Gothic cathedrals and English bridges on the copper. As if the etcher's job was to do otherwise than to draw honestly on the plate his vision of life.

Evening Wind

1921. Etching, $6\frac{7}{8} \times 8\frac{1}{4}''$
Philadelphia Museum of Art
Purchased: The Harrison Fund

This etching can be considered a modern-day Annunciation, a reworking of the myth of the seduction of Danaë by Zeus who appeared as a shower of gold, or more simply, an intimate view of an ordinary event. It is a haunting image that joins American Landscape *in signaling Hopper's maturity, his understanding of the alienation of modern life, and the fears that haunt inhabitants of the twentieth century.*

51

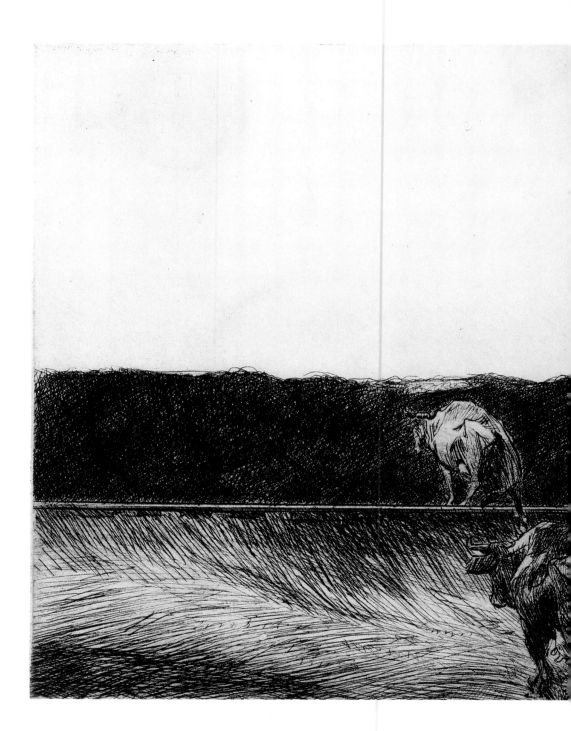

In view of the great number of illustrations that Hopper produced in the late teens and early twenties, etching seems in retrospect to have been a perfect medium for him because it permitted him to critique Sloan's New York City Life etching series. Hopper reoriented these works so that the human condition became the main subject; he began to suspend the narrative, which had been important to Sloan. In this manner he gained a new means of control over his art and his life: if he couldn't critique his own illustrations, which were made for major corporations bordering on trusts

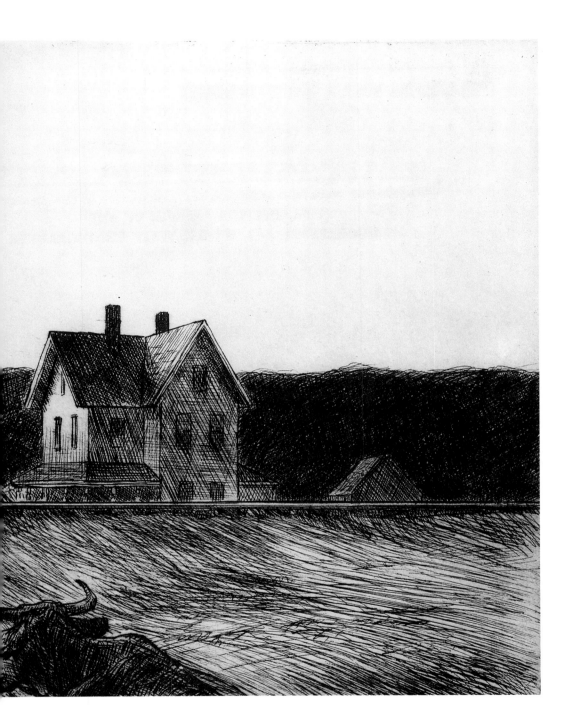

American Landscape

1920. Etching, 7⅞ × 9⅞"
Philadelphia Museum of Art
Purchased: The Harrison Fund

The railway track pictured here becomes the occasion for considering how trains have interrupted a traditional American landscape. Since farmers and railway people were fighting over high rates and rebates to special clients in the first decades of the century, Hopper's print can be taken as a picture of the farmer's plight.

because they supported him, then he could take on a most important group of twentieth-century American etchings and use them as a basis for his art.

Since only the most powerful of Hopper's etchings are now generally known, it is important to make a few comparisons between prints that function as art and those works that border on illustration. Among his more mature etchings are *American Landscape* (1920), *East Side Interior* (1922), and *The Lonely House* (1923), while the prints *House on a Hill (The*

Buggy) (1920), *Les Deux Pigeons* (1920), *Summer Twilight* (1920), *People in a Park* (n.d.), *House Tops* (1921), and *Railroad Crossing* (1923) are more clearly related to his illustrations. The reasons for the maturity of one group is apparent on inspection: the mature works provide a straightforward view of the contemporary human condition and reject obvious narration while the more illustrative prints succumb to story-telling and sentiment. In light of Hopper's part-time job at this time as a successful commercial illustrator, his achievement in eschewing obvious story-telling devices and ingratiating images in some of these works is remarkable.

A few comparisons between Hopper's successful and unsuccessful etchings will demonstrate the significance of his rigorous view of the world and his ability to frame a dilemma and hold it in suspension so that viewers are faced with puzzles rather than solutions. At first glance the dairy cows in *American Landscape*, which wearily trudge over the railroad tracks to the farmhouse in the background, seem to form the basis of an easily understood story. But when their actions are viewed in relation to the entire print—which comprises railroad tracks that cut across a farm and separate the field from the farmhouse and its outbuildings—their return home suggests more a daily ritual than an isolated event. The print conveys the idea that the American landscape of the 1920s is an interrupted landscape. Within the confines of this small print, Hopper suggests that trains encompass great expanses and are thus out of sync with small farms which are based on distinct limits: he uses the bold horizontal line formed by the railroad tracks, which disrupts the farm and extends across the width of the print to convey this idea. In contrast to *American Landscape*, which becomes an emblem of the conflicts between industrial and agrarian points of view, *Railroad Crossing* (1923) trivializes these same forces by limiting them to a specific event. Instead of being a constant interruption, the railroad functions as an occasional problem.

The conflict symbolized by the railroad tracks and the farm in *American Landscape* points to the battles being waged between farmers and railway companies in the first decades of this century. In 1903 the Elkins Act put limits on the rebate practice of railway companies and made it a misdemeanor for them to deviate from their published rates. In 1906 the Hepburn Act endowed the Interstate Commerce Commission with the power to fix just and reasonable maximum rates for railroads and to set forth uniform methods of accounting for these companies. But despite these measures early in the century, the Progressive Party nominee Senator Robert M. La Follette of Wisconsin could point out in 1924 that railway companies had helped to create a situation that had severely hurt American farmers who were suffering "an emergency of the gravest character."

Railroad Crossing

1923. Drypoint, 7 × 9″
The Metropolitan Museum of Art, New York City
Harris Brisbane Dick Fund, 1925

This etching is a genre scene, an anecdote from everyday life that differs from the iconic quality of American Landscape.

TRANSITION: THE ETCHINGS

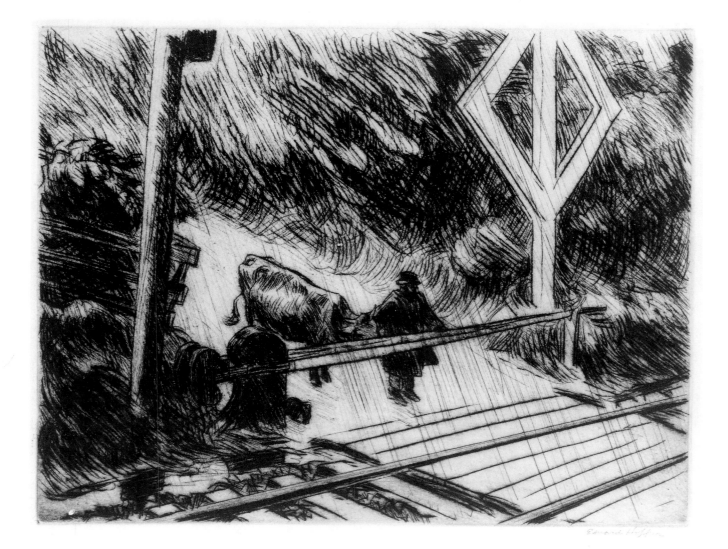

Railroad Crossing

In addition to a host of policies and legislation that had served to make American industries into monopolies and thus deflate the farmer, the government had "guaranteed excessive freight rates to the railroads." While La Follette's speech contains much of the fervor and idealism of the old-time Progressives and may well slant the facts in favor of his own viewpoint, farmers in general suffered in the 1920s and almost a third of America's wheat farmers went bankrupt between the years 1920–24.

Similar to the way *American Landscape* differs from *Railroad Crossing* in terms of symbolizing a conflict rather than presenting a familiar story, *Night Shadows* (1921) contrasts with *Summer Twilight* (1920). In *Night Shadows*, Hopper makes use of the bird's-eye view of Impressionism to a dramatic new purpose. Rather than employing the high point of view to celebrate the new elevations of the modern city and to present a panoply of festive crowds gathered on grand boulevards and city parks as the French Impressionists did, Hopper uses an unusual orientation to emphasize the isolation of the solitary figure on the street below and to place in question the invisible viewer who takes in this scene from above. What is the pedestrian doing, and why is he being looked at from above? Does the viewer have nothing else to do? Is the viewer waiting for someone? The print foreshadows Charles Sheeler's film *Manhattan*, Berenice Abbott's photographs of New York, and many scenes from 1940s and 1950s *film noir;* it also anticipates the development of the mysterious narrator who becomes a symbol of the unknowable self in Alain Robbe-Grillet's innovative novel *Jealousy,* for like Robbe-Grillet's viewer, the onlooker of Hopper's *Night Shadows* is provided with a distinct role and vantage point even though his or her identity is left in question. And similar to Robbe-Grillet's viewer, the motives of Hopper's onlooker can never be figured out from the clues provided. *Night Shadows* calls to mind other mysterious images of city streets such as De Chirico's *Melancholy and Mystery of a Street.* In this painting De Chirico takes an Italian city that is almost deserted in August and uses it as a basis for his nightmarish world, while in *Night Shadows* Hopper employs the standard fare of an American town—a streetlight, fire hydrant, and corner drugstore—to convey a haunting image of isolation in America. The ordinary nature of the buildings and street endows the work with poignancy since it suggests that the drama could occur anywhere in the United States.

In contrast to *Night Shadows, Summer Twilight* is less mysterious and more clearly aligned with Hopper's commercial work. In *Summer Twilight* the viewer lacks the mystery of the onlooker of *Night Shadows* and becomes a casual and predictable bypasser. The Queen Anne and Stick Style houses in this etching indicate an older and more pretentious world, and

Night Shadows

1921. Etching, 7 × 8⅜"
Philadelphia Museum of Art
Given by Carl Zigrosser

The artist employs the standard fare of an American town—a streetlight, fire hydrant, and corner drugstore—to convey a haunting image of isolation in America. The perspective of a bird's-eye view heightens the mystery of the ordinary and calls into question the motives of the invisible viewer looking down on this scene.

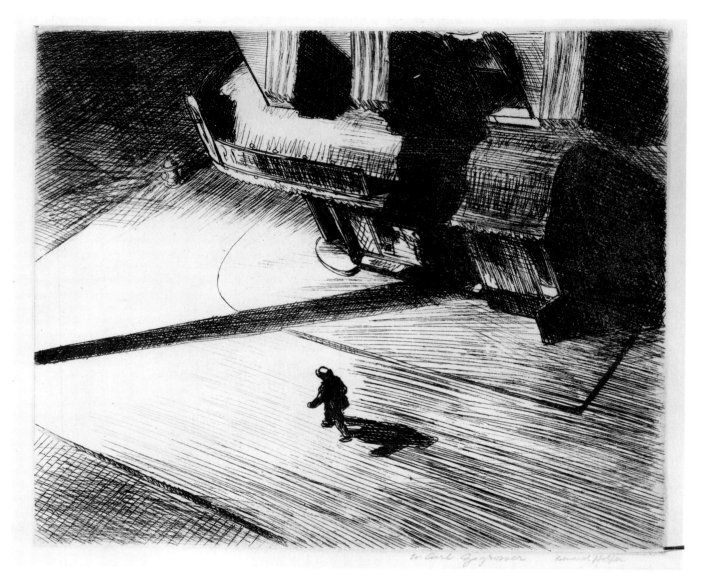

Night Shadows

the couple in the front lawn of one house continues the genteel tradition of gracious nineteenth-century living into the twentieth century. Hopper's vision in *Summer Twilight* is affirmative; the quasi-Gothic Revival houses in this etching do not hint at traces of decadence in America, at the Gothic core that Hopper later alludes to in *House by the Railroad,* which becomes a twentieth-century equivalent for Hawthorne's *House of Seven Gables.* In *Summer Twilight* Hopper illustrates only a scene from everyday life, while in *Night Shadows* he creates a disturbing icon of the alienating effects of the American city.

Of all Hopper's etchings *Evening Wind* (1921) most clearly manifests his ability to find convincing modern-day equivalents for traditional subject matter. In this print he submerges traditional subject matter in an aura of mystery. *Evening Wind* can be regarded as a modern-day Annunciation. Although the figure in Hopper's print might be getting out of bed to close the window, her orientation suggests that she might also be climbing into an unmade bed, and her nudity indicates her vulnerability and possible receptivity to the wind, which could be viewed as a symbol of the spirit or the Holy Ghost, which is sometimes represented by a dove, an emblem of the unborn soul. To appreciate this scene one does not have to read it in relation to earlier art, and it is possible that Hopper did not consciously think of his etching as an Annunciation even though his subject does represent a secularization of it or a modern-day version of its pagan counterpart, the story of the seduction of Danaë by Zeus who appears as a shower of gold. This Greco-Roman myth was also the subject of important paintings by Titian and Rembrandt, the latter an artist Hopper held in high esteem. Knowing the art historical references for depictions of females consorting with divine entities adds to the meaning of *Evening Wind,* and Hopper may have inverted tradition to a completely new end, for he has characterized the implied viewer of this etching as someone who is in the room with the girl.

Hopper's art, as *Evening Wind* convincingly demonstrates, is a still in a film that the viewer helps to direct. It needs the force of tradition without its limitations and the allusions to a well-known story without a clearly discernible plot to be effective. Hopper's art depends on ambiguity because the lack of a prescribed story line invites viewer participation. His work remains a question mark, and what it does not permit us to know is as important as what it does. The majesty and force of traditional art endows *Evening Wind* with a range of associations that far exceeds the limits of this particular image. The etching can allude to a number of scripts without specifying one; it serves as a catalyst for an observer's reactions, and it sets up an interactive process that communicates the art's range of meaning.

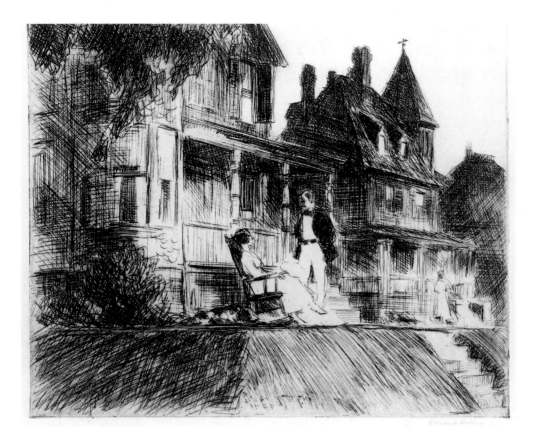

Summer Twilight

1920. Etching, 8½ × 10″
Philadelphia Museum of Art
Purchased: The Harrison Fund

Summer Twilight *is a gently nostalgic image that recalls the gentility of large Victorian and turn-of-the-century houses, and is not concerned with the difficulties of the contemporary world.*

In *Evening Wind* the viewer, similar to the spectator in *Night Shadows,* is a mystery. Just as viewers of this print are cut off from the woman, so they are also alienated from themselves: their true motives and identity are subject to question and change. In this manner Hopper conveys the feeling of alienation that must be experienced by observers in order for the true subject of his art to be comprehended. Hopper's art then is not an illustration of an idea; it is an equation for feeling.

Drug Store

IV. Maturity

IN *Evening Wind* and *Night Shadows* Hopper provides viewers a means for participating in the experience of the work of art. He suggests a feeling without illustrating it, and thus finds a means of exploration that plummeted him into maturity and into overnight acceptance as a great American artist. In his mature works Hopper rarely creates secularized versions of sacred stories and myths; instead he frequently emphasizes the new orientation to the American landscape afforded by the automobile. In the 1920s he used this approach as a basis for a group of works that pictures a developed industrial culture on the move. He put people in the situation of having to question why they deemed these subjects worthwhile and significant. In his best pictures his realism is as focused on the viewer who looks at the art as it is on the scene he paints. The paintings spark a range of feelings associated with alienation and loneliness. Although these feelings are sometimes acted out by people in the pictures, they are usually implicit in the way a particular situation is approached and in the psychological disposition the act of seeing assumes. The artist, in other words, looks both at his canvas and at the assumed viewer, and the work of art functions as a mirror that reflects a specific scene and also the type of observer constructing it. Because of this dynamic interaction, Hopper no longer has to succumb to story-telling in order to move viewers. He can make his pictures appear low-key and almost offhand because he is aware of the fact that an unresponsive look at a desolate landscape and an abandoned house mirrors the unconcern of many people in the 1920s who were too caught up in the freneticism and hedonism of their times to note the problems that were being created in the name of the progress. His orchestration of this dynamic has resulted in a new means for characterizing tensions among culture, nature, and technology, which were then regarded as progress.

Hopper's realism takes a special form. It is not as objective as it might first appear because the artist has found external equivalents for inner states in the form of buildings, desolate city streets, and overgrown fields. In the three major statements he made about art—his Museum of Mod-

Drug Store

1927. Oil on canvas, 29 × 40″
Courtesy Museum of Fine Arts, Boston
Bequest of John T. Spaulding

The painting's reference to Ex-Lax may be an ironic comment on American society's need in the 1920s to rid itself of its anal-retentive bent, to become less materialistic and less concerned with making a fortune on the then-rising stock market.

61

ern Art catalogue statement of 1933, his October 29, 1939, letter about *Manhattan Bridge Loop* to Charles H. Sawyer, director of the Addison Art Gallery of American Art, and his short piece for the spring 1953 issue of *Reality*—Hopper emphasized that his art is "the most exact transcription possible of my most intimate expression of nature," and "a synthesis of my inner experience." "Great art," he wrote in 1953, "is the outward expression of an inner life in the artist, and this inner life will result in his personal vision of the world. No amount of skillful invention can replace the essential element of imagination." If we are to believe Hopper—and it is difficult to question seriously his understanding of his aims when he repeats the same ideas over twenty years—his art is extremely personal. He regards it as more subjective than abstract painting even though his gaze might appear to be more focused on the American scene than on himself.

His self-portrait (1925–30) reveals his special way of being both public and private at the same time. In this painting one discerns simultaneously Hopper's vulnerability and his attempts to mask it. One cannot tell whether Hopper is sitting or standing. Because he is wearing a hat, one supposes that the artist is on his way out of doors or is returning from an errand and that he has stopped momentarily to glance at the mirror that the painting represents. He looks warily at himself and seems to be distrustful of his feelings at the same time that he records them. The hat serves to mask Hopper's patient observation of himself, his concern with his intensity and his vulnerability. The painting thus demonstrates the way Hopper uses his subjectivity and at the same time attempts to distance himself from it so that it can become another aspect of his overall realist style.

Throughout his life Hopper stated that his art was not an exact transcription of nature; it was a condensation of many scenes and impressions. "I'm always at a loss when asked for facts about any of my pictures or to describe how any one of them came to be made," he told Lloyd Goodrich. "It is so often a very complicated mental process that would not interest people." Hopper's art depended on memory as well as inspiration. He searched for a typical scene, not a unique one, and found he frequently had to cull from a number of experiences and reduce them to a common denominator to make his art. The real world was often too unique, and a specific locale frequently did not render the commonality of the true "American scene," a term he later learned to hate because it became associated in many people's minds with a nostalgic and Romantic view of the world. His description to Lloyd Goodrich of the origins of *Room in New York* (1932) underscores his method of creation:

The idea for Room in New York *had been in my mind a long time before I painted it. It was suggested by glimpses of lighted interiors seen as I walked along the city*

[Self-Portrait]

1925–30. Oil on canvas, 25 × 20⅜"
Whitney Museum of American Art, New York City
Josephine N. Hopper Bequest
70.1165

Hopper looks warily at himself and seems to be distrustful of his feelings at the same time he records them. The hat suggests he is on his way outdoors and has stopped momentarily to observe himself in the mirror; it thus serves to mask his patient observation of himself, his concern with his intensity and his vulnerability.

[Self-Portrait]

Room in New York

streets at night, probably near the district where I live (Washington Square), although it's no particular street or house, but it is rather a synthesis of many impressions.

Hopper's ideas are more in line with some of the concepts underlying the art of Thomas Eakins, whom Hopper believed to be America's greatest painter, and the attitudes of Ralph Waldo Emerson, than they were with many of his contemporaries. "I admire Emerson very much," Hopper told Brian O'Doherty, "of course he wrote no fiction. It's all philosophy. I admire him greatly," he reiterated. "I read him a lot. I read him over and over again."

Hopper upholds the grand tradition of nineteenth-century American thought, and he brings aspects of Transcendentalism into a new confrontation with life. He continues Emerson's belief in the self as a center for all knowledge even though he avoids transcendence as a romantic escape from reality. Hopper joins Emerson's self-reliance with Eakins's pragmatism and forges a new realism that has nineteenth-century roots and a distinct twentieth-century point of view. His realism depends mainly on the orientation of the implied viewer. Although his figures seem to be lonely or loners, yearning or wistful, and certainly a long way from Emerson's self-reliant ideal, his art in actual fact forces viewers to come to terms with these interrupted narratives and to rely on their own interpretations. Thus Hopper does not illustrate self-reliance; he choreographs situations in which the viewer is forced to become self-reliant. Moreover, he pictures important changes in America without forcing a false morality on his viewers. He usually does not weigh the evidence in his favor as does his contemporary Burchfield, who creates images of the rural downtrodden who have been left behind in the wake of progress. Although he was concerned with persuading viewers to come to definite conclusions in his own art, Burchfield recognized Hopper's contribution. In a brief essay for The Museum of Modern Art retrospective in 1933, Burchfield wrote:

Some have read an ironic bias in some of his paintings; but I believe this is caused by the coincidence of his coming to the fore at a time when, in our literature, the American small towns and cities were being lampooned so viciously; so that almost any straightforward and honest representation of the American scene was thought of necessity to be satirical. But Hopper does not insist upon what the beholder shall feel. It is this unbiased and dispassionate outlook, with its complete freedom from sentimental interest or contemporary foible, that will give his work the chance of being remembered beyond our time.

Room in New York

1932. Oil on canvas, 29 × 36″
Sheldon Memorial Art Gallery,
University of Nebraska-Lincoln
F. M. Hall Collection

The viewer implied in this painting is a city dweller who, like a voyeur, knows intimate aspects of strangers' lives. Hopper has chosen to blur the facial features of the couple here and shows them as types, thus indicating that our view of their world does not allow us to understand them as individuals.

Charles Burchfield
Winter Solstice

c. 1920–21. Watercolor on paper, 21½ × 35½"
Columbus Museum of Art
Gift of Ferdinand Howald

Hopper regarded Charles Burchfield as a peer, and was particularly interested in his paintings, illustrating the plight of the rural downtrodden.

From Emerson, Hopper chose selectively. He regarded "Self-Reliance" as an important guide to solving essential problems of life, and he agreed with Emerson's idea that there is "really nothing external, so I must spin my thread from my own bowels." Hopper appears to follow in his art Emerson's idea about an underlying "correspondence between the human soul and everything that exists in the world." Such correspondences can exist because the world, as pictured in Hopper's art, is never a simple visual fact; it is connected to an observer, and particularly to a framework that specifies a mode of interaction without determining its results.

Hopper also develops in his work a disjunction that approximates Emerson's primordial schizophrenia, his idea that the world was originally split into mind and nature. This split has already been mentioned in relation to Hopper's Paris paintings and is also symbolized in his *American Landscape*, where nature is a farm and the mind can be equated with the clear-cut, inexorable logic of a railroad track which accomplishes its objective even though it interrupts another system. Differing from Emerson, though, Hopper does not regard human culture as capable of integrating the primordial schizophrenia; all his own art can do is to show how these tensions work in the modern world.

Although Hopper referred to Emerson's writings throughout his life and attached himself to some of the ideas of the American Transcendentalists, he cannot be considered a latter-day adherent of this group because he rejected the soothing and healing effects of art and literature, which the Transcendentalists thought capable of reintegrating the inherent dichotomy between mind and nature. While Hopper has accepted the

Gustave Courbet
La Mère Grégoire

1855. Oil on canvas, 50¾ × 38¼"
The Art Institute of Chicago
Wilson L. Mead Fund, 1930.78

Courbet is credited with discovering Realism. A more appropriate assessment would be that Courbet understood the needs of the recently formed bourgeois audience and painted them. He said, "Show me an angel, and I will paint one." But he relied less on strict visual information than one might imagine. His subjects are usually conceived in thick paint and dramatic brushwork. Courbet's real contribution, as La Mère Grégoire *convincingly demonstrates, is to put the viewer on a par with his new bourgeois subject and make both part of the contemporary world.*

Transcendentalists' romantic love of ancient Greek, Roman, and medieval ruins and their concern with the passing of time, he separated these concepts from nineteenth-century nostalgia and made his ruins contemporary: they have become abandoned farmhouses, Victorian mansions, desolate city streets, the unrelieved skyline of brownstones and chimneys characteristic of Brooklyn and many other cities. Hopper would have agreed with Emerson's estimation of the values of civilization as "essentially one of property, of fences, of exclusiveness," but he would have dis-

Édouard Manet
Olympia

1863. Oil on canvas, 51⅛ × 74¾″
Musée du Louvre, Paris

In this painting Manet continued Courbet's Realist goals and made the act of looking and being looked at his subject matter. Here Olympia's glance makes the viewer a voyeur and a possible client for this woman who is posed as a member of the Parisian demimonde.

agreed with Emerson's belief in art's ability to reintegrate humanity's rationality with nature. Art, for Hopper, is a catalyst that forces people to see the twentieth century in terms of an alienated self. Unlike the Romantics who posited a universal yet hazy vantage point outside time, or the Ash Can painters who distance and comfort viewers by making them bystanders to illustrated, contemporary adventure stories, or his contemporary Reginald Marsh who turns Coney Island into a modern-day equivalent to a Renaissance or Baroque genre scene and observers into aesthetes, Hopper forces his viewers to interact with twentieth-century scenes from the vantage point of a contemporary and alienated human being. He provides them with partially written scripts and clear stage directions about their location, and then he leaves them to write their own conclusions.

The idea of writing a script for the viewer, of giving him or her a place in relation to the work of art is implicit in all art. In mid-nineteenth-century France, however, Realist art attempted to choreograph the very specific and pragmatic outlook of bourgeois observers. Gustave Courbet, the great Realist, made the viewer's limited background a working premise for his art, which ceased to project classical allusions unfamiliar to most of his audience. Even in such a simple and seemingly unassuming picture as *La Mère Grégoire* he infuriated Parisians because he dispensed with the idea that a portrait is an absolute illusion far removed from the casual glance and comments of ordinary people and took the revolutionary course of inviting his observers to sit across Mère Grégoire's table and in-

Thomas Eakins
Miss Amelia C. Van Buren

c. 1889–91. Oil on canvas, 45 × 32″
The Phillips Collection, Washington, D.C.

The disparity between the tradition of the elegant portrait and the actual situation of painting a very human and unheroic individual is the focus of Eakins's art. Eakins drives a wedge between expectations and reality, and thus makes viewers aware of the differences between artistic convention and an unabashed new art. In this painting Eakins allows viewers a private look at a complex individual who is not acting out any other scenario than simply being herself.

teract with her. Similarly, Manet upset his audiences by forcing them to interact with *Olympia,* a portrait of a woman who looked like a modern-day courtesan and who seemed to be brazenly calculating all passersby as potential clients. This realism that admitted the presence of specific types of viewers became a basis for the Impressionist glance. Less radical but still involved in this new form of realism are the portraits made by Thomas Eakins. In these works the invisible wall of proscenium stage theater that sep-

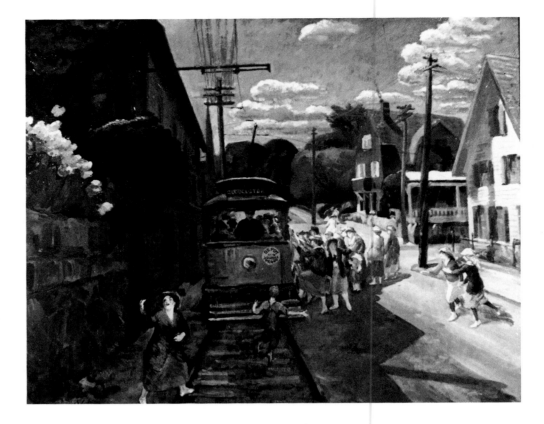

John Sloan
Gloucester Trolley

1917. Oil on canvas, 26 × 32"
The Canajoharie Library
and Art Gallery, New York

In spite of being a social activist, Sloan does not continue the egalitarianism of Courbet, Manet, and Eakins. In Gloucester Trolley, *viewers are provided with an elevated vantage point that enables them to be removed from the contemporary world and thus idealize it.*

arates the audience from the painted image is removed as it is in the works of Courbet and Manet. Viewers are no longer looking at grand and noble portraits of important personages; they are standing before ordinary individuals with real problems and everyday discomforts who have entered Eakins's studio.

With the art of the Ash Can School, Eakins's particular form of realism unfortunately ceased to prevail, and ordinary people were again cast in conventional artistic roles. Ash Can paintings demand that viewers become a traditional art audience and insist that the invisible wall of proscenium theater slip down in front of them and separate them from the art. In Ash Can painting the viewer becomes once again universal and anonymous.

In the early 1920s Hopper began to penetrate this invisible wall. The relative lack of success of much of his earlier work, excepting the paintings of Paris, stems from the denial of the actual presence of the viewer and the assumption that onlookers are not to be challenged: they must be entertained and consequently lulled into a false sense of security about modern life, which is just another exciting adventure story or charming landscape. And the success of Hopper's mature work depends on the way viewers are forced to leave their seats and perform the roles he has scripted for them.

Although Hopper understood the important advances in Realism made by Courbet, Manet, and Eakins and managed to expand Emerson's

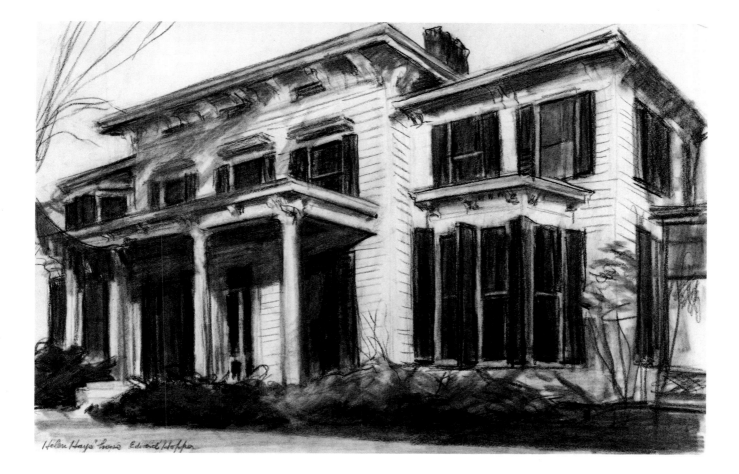

Drawing for painting
Pretty Penny

1939. Conté on paper, 10½ × 16″
Whitney Museum of American Art, New York City
Josephine N. Hopper Bequest
70.681

The actress Helen Hayes has recalled how Hopper came to depict her house shown here: "In about 1937 or 1938, Charlie had the bright idea of having Hopper—who had been born in Nyack, who lived in a real Hudson River bracketed house, a tiny house down the street there from us—paint our house...like House by the Railroad. *'Well,' [Hopper] said, 'I can't paint it. There's no light and there's no air that I can find for that house.' He...wait-ed for summer to pass and autumn to pass and then came February, when he had plenty of his so-and-so air and light, and he came back and he was seated out there in the bitter cold drawing the house. ... And finally, when [the second] day was over, he did come in with some extraordinarily fine drawings that are now in the Whitney Museum." (Hopper Symposium, Whitney Museum of American Art, 1980)*

self-reliance so that it extended to the onlooker's role, his art would not be important if it did not delight viewers and entice them into the game of acting out the illusions provided. Hopper was intrigued with the changes in modern life, and he found new ways to dramatize his impressions. His *Automat* (1927) is a case in point. In this work Hopper took the new emphasis in the 1920s on short skirts and silk stockings and made them the focus of his painting of a solitary female. Whatever one might think about the phenomenon of the automat—which depends on the paradigm of mass production for preparing and dispensing food and the isolation at mealtime that it implies—Hopper has dramatized alienation in a new way by making the viewer a voyeur who focuses on the girl's legs, which form the brightest spot in the painting. Absorbed in her own thoughts, the girl becomes an object in this painting, a luscious piece of fruit comparable to the fruit in the glass compote behind her. In this painting Hopper creates a situation far removed from the conviviality of French Impressionist art. He comments on alienation, but he places viewers in the uncomfortable role of increasing this alienation by focusing on the girl's legs and turning her into an object of desire.

Hopper did not discover in one work his true subject matter and method and then continue it for the rest of his life. He floundered on occasion and created images of the American scene instead of the twentieth-century human dilemmas of alienation, self-absorption, and voyeurism. Some of his watercolors, such as *The Mansard Roof* (1923), contain the right subject matter without the astringent point of view that characterizes *House by the Railroad*. *The Mansard Roof* is less a symbol and more a portrait of a particular dwelling; it incorporates little of the spectral emptiness of *House by the Railroad*—an image of progress and obsolescence coupled with the vantage point of an onlooker who may be situated in a moving vehicle.

The success of the first Rehn Gallery exhibition enabled Hopper to paint full time. Immediately after this exhibition Hopper created a large body of art, and he also ventured further into the area he had already staked out for himself in his etchings. In 1924 and 1925 he made some remarkable watercolors of the New York City skyline, which represent as formidable a departure as *Night Shadows*. In *Skyline Near Washington Square* (1925) a solitary brownstone stands above the roofline of the other buildings. One looks across the roof of one building to see this strangely isolated structure. Though the composition of this watercolor is carefully articulated, it appears accidental and causes one to reflect on why he or she is looking at this particular building, memorable only because it is still standing. The scene thus brings one back to the viewer and causes one to question where the vantage point is. Has Hopper placed the viewer on a roof or in a

Automat

1927. Oil on canvas, 28⅛ × 36"
James D. Edmundson Fund
Des Moines Art Center

In this painting of a solitary female, Hopper emphasizes the new 1920s look of short skirts and silk stockings and makes them the focus of his painting. The girl's legs form the brightest spot on the canvas, and the viewer is drawn into the uncomfortable position of staring.

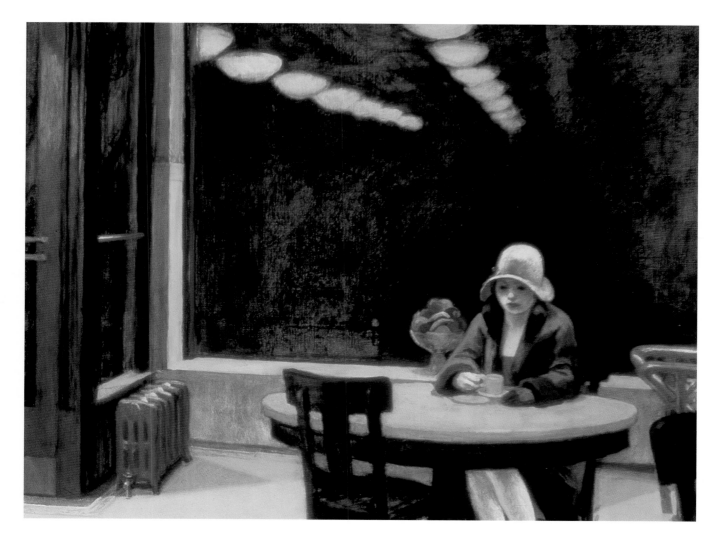

Automat

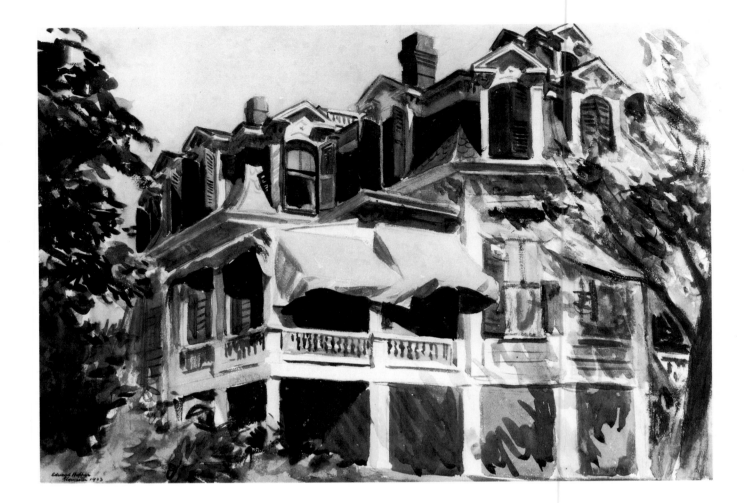

The Mansard Roof

1923. Watercolor over pencil on paper, 14 × 20″
The Brooklyn Museum, 23.100
Museum Collection Fund

This watercolor was the first of Hopper's works to enter a museum collection. Always fascinated with architecture, Hopper made many watercolors and paintings of houses. His characterizations of Victorian and turn-of-the-century houses were to have a major impact on photographers and Sunday painters who viewed them nostalgically and who failed to see them as symbols of obsolescence.

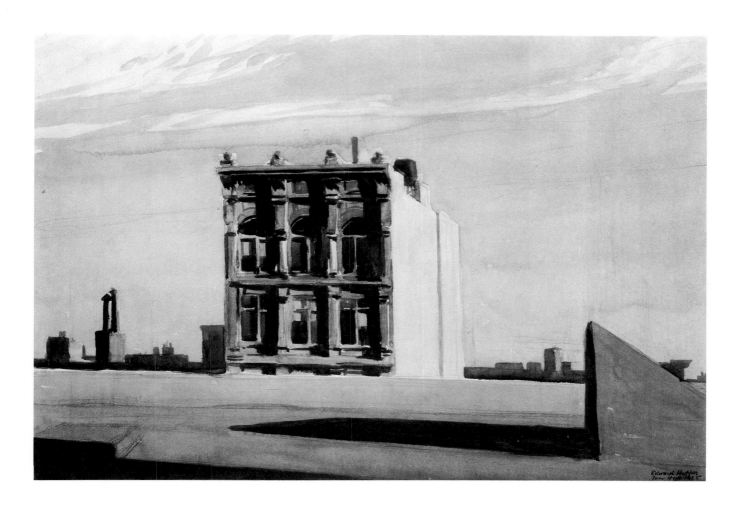

Skyline Near Washington Square

1925. Watercolor on paper, 15 × 21¼"
Munson-Williams-Proctor Institute,
Museum of Art, Utica, New York

This austere view of an isolated New York building symbolizes the alienated individual in the twentieth century. Separated from other row houses, the building is a remnant of another period, a reflection of a time when such structures formed part of a community of similar individualized façades.

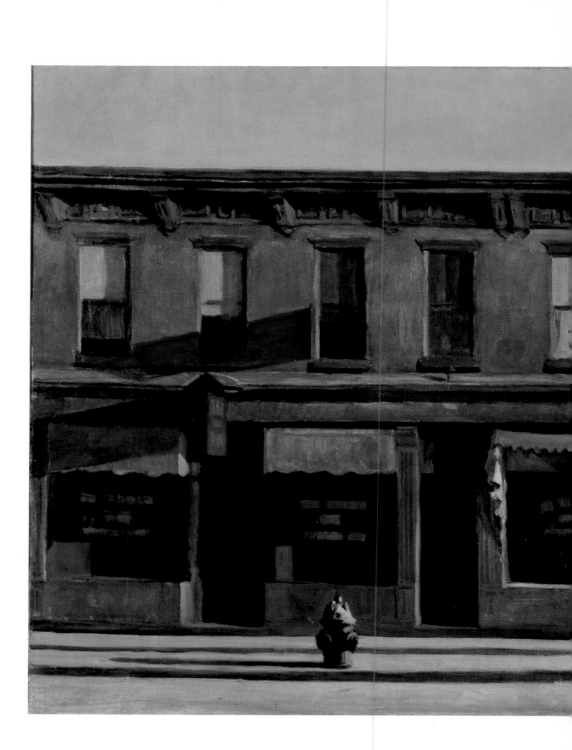

similar brownstone? Is this banal cityscape the only interesting thing to look at? What has happened to the American dream or to the promised land pictured in the nineteenth century by Thomas Cole, Albert Bierstadt, and so many others? The watercolor is, thus, about loss, the breakup of an American tradition, and the individual imprisoned in the modern city.

Hopper continued this theme in other works. Particularly affecting is his *Manhattan Bridge Loop* (1928), which so clearly contrasts with the series

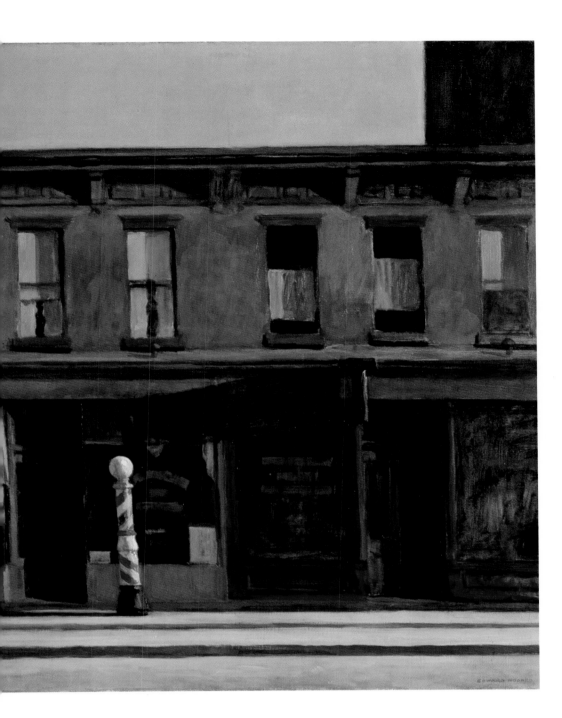

Early Sunday Morning

1930. Oil on canvas, 35 × 60"
Whitney Museum of American Art, New York City
31.426

Although the artist referred to this painting as "almost a literal translation of Seventh Avenue" in New York City, it can be considered an image of the enduring strengths of small service-oriented businesses throughout the United States that managed to withstand difficulties of the Great Depression and sometimes even to prosper.

of homages to the Brooklyn Bridge that Joseph Stella first began exhibiting in 1920. Instead of turning the modern bridge into a new Gothic cathedral of industrialization with Cubist overtones as Stella does, Hopper emphasizes its unheroic qualities and places a solitary pedestrian on the *Manhattan Bridge Loop*, thus dwarfing him with acres of concrete. Unlike Stella who puts the viewer in the center of the composition to form the symbolic nexus for the matrix of lines representing the Brooklyn Bridge's suspension system, Hopper places the viewer off to the side and then lets

MATURITY

77

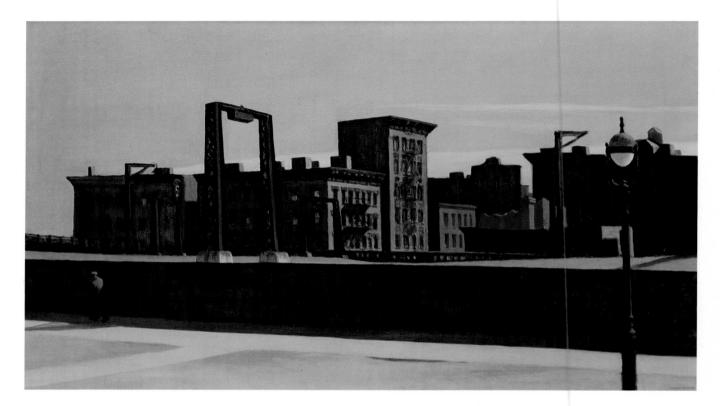

Manhattan Bridge Loop

him or her question the importance of the scene and the reason for its being painted. The horizontal format of this painting is crucial to its meaning. The breadth of the picture acts as a wide-angle lens to emphasize the fact that cities can be uneventful and dehumanizing. Choosing the proportions for a painting was a matter of great concern to Hopper. Unlike many artists who use standard sizes, he carefully considered the proportions for each work as his comments about *Manhattan Bridge Loop* indicate:

I spend many days usually before I find a subject that I like well enough to do, and spend a long time on the proportions of the canvas, so that it will do for the design, as nearly as possible what I wish it to do. The very long horizontal shape of this picture, "Manhattan Bridge Loop," is an effort to give a sensation of great lateral extent. Carrying the main horizontal lines of the design with little interruption to the edges of the picture, is to enforce this idea and to make the scene itself. The consciousness of these spaces is always carried by the artist to the very limited space of the subject that he intends to paint, though I believe all painters are not aware of this.

In the 1920s Hopper created several paintings that deal with the line of buildings constituting a city block. Architecture plays a major role in much of his work. He admitted that when he was making illustrations, "I was always interested in architecture, but the editors wanted people waving their arms." Frequently his buildings are protagonists that personify cultural and social concepts. In some works he turns the architecture into the equivalent of the railway tracks in *American Landscape* and *House by the Railroad*. Although the structures he paints might appear to signify the unrelenting march of progress, some in fact symbolize the mass of isolated individuals in America, the solitary shopkeepers, such as the man sitting on the boardwalk of *Sunday* (1926). This man could be a representative of a laissez-faire economy of small shopkeepers who are tied to the nineteenth-century architecture of their storefronts and to nineteenth-century ideals as well. Significantly this man's situation is ambiguous: though he is resting on Sunday, the shops behind him are empty and show no sign of being occupied. The painting *Sunday* thus allows the viewer the option of choosing alternative meanings: the picture can be taken as a pleasant scene of a middle-aged man puffing on a cigar and enjoying the sunlight, or it can be regarded as a picture that presents indirectly the unprosperous side of the 1920s. During this decade New England shopkeepers and local citizens were suffering because shoe manufacturers were closing down their old plants to establish new ones in Illinois and old textile mills in New England were being similarly abandoned in favor of new ones in Virginia, North Carolina, and Georgia. If one views this picture as an im-

Joseph Stella
New York Interpreted: The Bridge

1922. Oil on canvas, 88¼ × 54″
The Newark Museum, New Jersey
Felix Field Bequest

Joseph Stella transforms the cables of the Brooklyn Bridge into an abstract pattern testifying to the strengths of industry and the power of the present-day world. His optimism differs radically from Hopper's realism as is evident in a comparison of New York Interpreted *and* Manhattan Bridge Loop.

Manhattan Bridge Loop

1928. Oil on canvas, 35 × 60″
Addison Gallery of American Art,
Phillips Academy, Andover, Massachusetts

Although this painting seems to be a straightforward image of an urban scene, Hopper intended it to be more. "My aim in painting," wrote Hopper, "is always, using nature as the medium, to try to project upon canvas my most intimate reaction to the subject as it appears when I like it most; when the facts are given unity by my interest and prejudices. Why I select certain subjects rather than others, I do not exactly know unless it is that I believe them to be the best mediums for a synthesis of my inner experience."

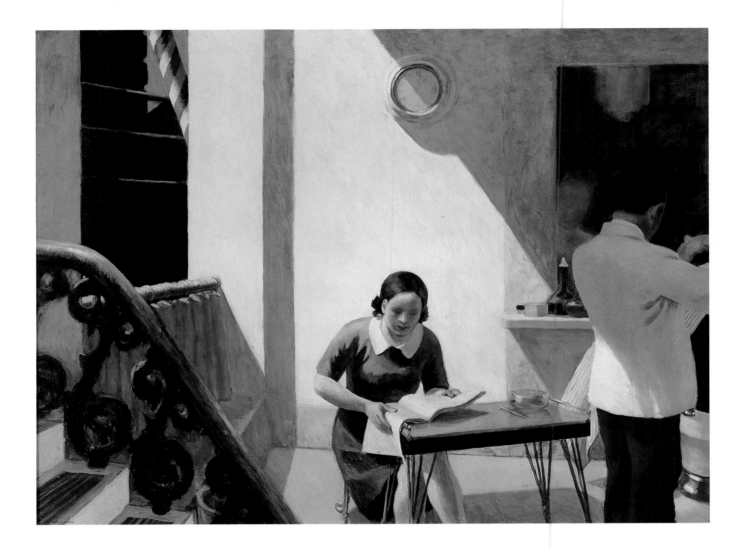

The Barber Shop

1931. Oil on canvas, 60 × 78″
Neuberger Museum,
State University of New York at Purchase
Gift of Roy R. Neuberger

This painting depicts one of the small-time businesses in the Depression that continued to prosper as it served the needs of a growing clientele.

Vincent van Gogh
Café Terrace at Night

1888. Oil on canvas, 31⅞ × 26″
Collection State Museum Kröller-Müller,
Otterlo, The Netherlands

Hopper's Drug Store *is an American equivalent to Van Gogh's* Café Terrace at Night. *However the differences between the two works are even more important than their similarities. Van Gogh intended to manifest his intense feelings through his choice of color. In contrast, Hopper avoids the personal and laconically symbolizes a cure for society's problem by picturing a window display of Ex-Lax.*

The City

age of a New England recession in the 1920s, then Hopper agrees with Eugene O'Neill who stated that the artist must "dig at the roots of the sickness of today...the death of an old God and the failure of science and materialism to give a satisfactory new one."

The ambiguity of *Sunday* is taken a step further in one of Hopper's most famous paintings, *Early Sunday Morning* (1930), a painting that can either be taken as a quiet and peaceful scene of small businesses that are closed or considered a comment on the Depression. Hopper pointed out in a conversation with Katherine Kuh in 1960 that the word Sunday was not part of the original title. "I'm fond of *Early Sunday Morning*, too—but it wasn't necessarily Sunday. That word was tacked on by someone else."

Although Hopper later stated that *Early Sunday Morning* "was almost a literal translation of Seventh Avenue," his painting appears less a specific picture of New York and more an image of America. Both the barber pole on the sidewalk and the white curtains in the second-floor apartment connote the life-styles of small-time business people throughout the United States. Originally Hopper had painted a person in the second floor window, but he later decided that the architecture conveyed his feelings and consequently painted out this individual. Although one cannot tell from the signs on the storefronts what kinds of businesses are represented except for the barber shop, the sizes of the buildings suggest that they provided inexpensive goods and services. During the Depression basic industries such as steel suffered, but small, service-oriented businesses selling shoes, clothes, food, drugs, and gas stayed in business, and some even prospered: gas stations, laundries, beauty parlors, and barber shops served a growing clientele. Hopper's *The Barber Shop* (1931) thus underscores the stability of the small-time business in the depths of the Depression. And the shops in *Early Sunday Morning*, which extend in a continuous line beyond the confines of the picture and reinforce the horizontal format of the canvas, emphasize the ubiquity of small-time businesses in the United States. On the upper-right corner of the picture, the dark brown passage of paint suggests the side of a large building and indicates the possible encroachment of the corporate world on this sunny block. Other shadows that are also cast from the right subtly imply that the small-time shopkeeper, the Progressives' symbol of the individual and the early nineteenth-century American ideal, is in conflict with larger, less clearly defined forces. In this manner the painting continues the Progressive ideal and obliquely refers to the shadowy realm of larger structures on the right.

Three years before *Early Sunday Morning* Hopper alluded to his feelings for the individual who is caught up in the problems of the modern metropolis. In *The City* (1927) he presents people dwarfed by tenements of

The City

1927. Oil on canvas, 28 × 36″
University of Arizona, Museum of Art, Tucson
Gift of C. Leonard Pfeiffer

This view of a Second Empire building surrounded by anonymous tenements augments Hopper's earlier painting House by the Railroad, *which presents a Second Empire house in a disrupted rural setting.*

Lighthouse Hill

1927. Oil on canvas, 28¼ × 39½"
Dallas Museum of Art
Gift of Mr. and Mrs. Maurice Purnell

Although lighthouses are traditionally romanticized, Hopper presented the Cape Elizabeth Lighthouse Station near Portland, Maine, matter-of-factly. He made a number of paintings of this lighthouse. At the time he was making these paintings, mariners were protesting the proposed dismantling of the west tower of Cape Elizabeth Light, and Hopper's art thus comes to memorialize the partial obsolescence of an important beacon of nineteenth-century transportation and industry.

no particular style, people who are obviously swallowed up by forces beyond their control. Individuality and culture are as fragmented and as absurd as the Second Empire building in this painting, which is surrounded, blocked, and even nudged by small, insignificant buildings.

Drug Store (1927), painted the same year as *The City,* is on first viewing more optimistic since the small-time pharmacy owned by Mr. Silber casts a beam of light in an otherwise dark environment. The painting calls to mind Vincent van Gogh's *Café Terrace at Night,* which might have been a source for the painting and an important point of reference since the Prohibition era drugstore, with its mandatory soda fountain, had replaced the traditional European bar. A poem by Hart Crane, written in 1923, provides a possible clue to the prominent reference to the laxative Ex-Lax in this painting.

America's Plutonic Ecstasies
(With homage to e.e. cummings)

preferring laxatives to wine
all america is saying
"how are my bowels today?" and
feeling them in every way and
peering
for the one goat (unsqueezable)
that kicked out long ago—

or, even thinking
of something—Oh!
unbelievably—Oh!
HEADY!—those aromatic LEMONS!
that make your colored syrup fairly
PULSE!—yes, PULSE!

the nation's lips are thin and fast
with righteousness and yet if
memory serves there is still
catharsis from gin-daisies as well as
maidenhairferns, and the BRONX
doesn't stink at all.

 These
and other natural grammarians are ab-
so-loot-lee necessary
for a FREEEE-er PASSAGE—(NOT
to india, o ye faithful,
but a little BACK DOOR DIGNITY)

Sunday

1926. Oil on canvas, 29 × 34″
The Phillips Collection, Washington, D.C.

A man who could be a shopkeeper sits on a wooden boardwalk before nineteenth-century storefronts. Because no goods are displayed in the windows, it is difficult to tell if the shops are closed or out-of-business, and if Sunday *signals a day of rest or points to the recession in the 1920s that affected many New England towns.*

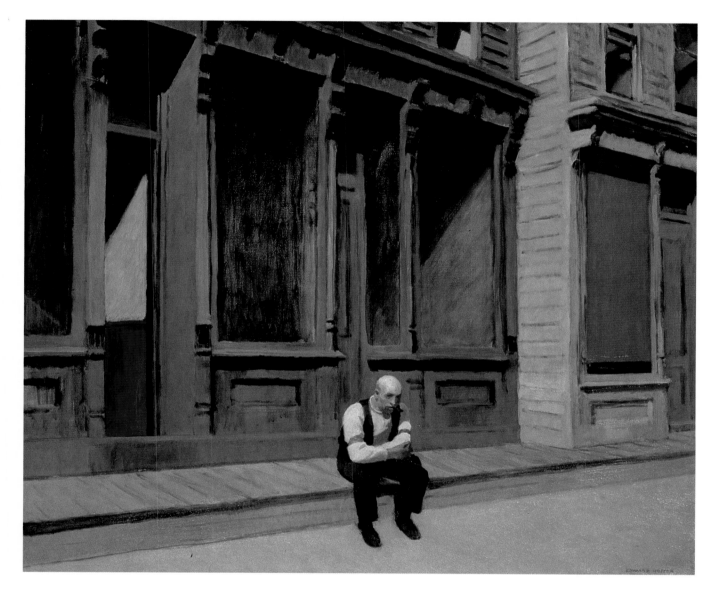

Sunday

Crane's poem obviously deals with Prohibition and the self-righteousness of an anal-retentive society. Hopper may be reflecting on this poem in *Drug Store,* which extols the entrepreneurship of Mr. Silber at the same time it makes fun of the materialistic values of Americans in the 1920s. In this painting the artist implies that both the nineteenth-century architecture of the drugstore, the nineteenth-century ideal role for the individual that it represents, as well as the reference to Ex-Lax might keep in check a materialistic society that seemed determined in 1927 to perpetuate the power of big business by playing the stock market. In comparison to *Sunday,* painted the year before and *Early Morning Sunday,* created three years later, *Drug Store* is highly ironic; it is a picture of a store that sells Ex-Lax, a product guaranteed to relieve society of its present ills.

Drug Store is also important because it is one of Hopper's first paintings to deal with Freudian concepts. Freud's writings were first translated into English about the time of World War I, and his ideas were quickly embraced by American intellectuals who began using the terms "repression," "Oedipus complex," and "anal-retentive." In the mid-1920s Hopper made a caricature of the artist as a boy holding books by Freud and Jung. And in 1939 he acknowledged the crucial role the subconscious mind plays in creation: "So much of every art is an expression of the subconscious that it seems to me most all of the important qualities are put there unconsciously and little of importance by the conscious intellect. But these are things for the psychologist to contemplate." In later works Hopper plays with Freudian ideas, but he keeps his symbols buried in everyday objects so that they are almost subliminal. *Sunlight in a Cafeteria* (1958) is a case in point, for the man and woman seated at separate tables are surrounded by a few objects that imply their emotional state. The man turns toward the window and holds a burning cigarette, and on the adjoining table a solitary and very phallic sugar dispenser indicates his interest in the woman, while another sugar dispenser is joined by an Aunt Jemima maple syrup container on the table in front of her to symbolize a prosaic, surrogate marriage. It is important to note that the couple does not look at each other; they are most likely strangers, and the tensions exhibited between them are thus alluded to by mundane objects on the table that underscore the picture's meaning.

Sunlight in a Cafeteria

1958. Oil on canvas, 40¼ × 60⅛″
Yale University Art Gallery,
New Haven, Connecticut
Bequest of Stephen Carlton Clarke, B.A. 1903

Although the woman's dress indicates that the season is summer, the light has a strangely cold effect and underscores the separation of these two people. This painting of a cafeteria harks back to Automat *(1927) and indicates Hopper's continued interest in picturing isolated individuals in public spaces.*

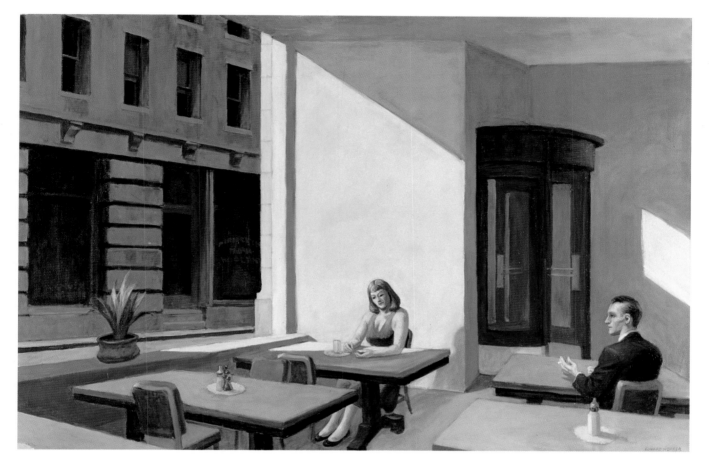

Sunlight in a Cafeteria

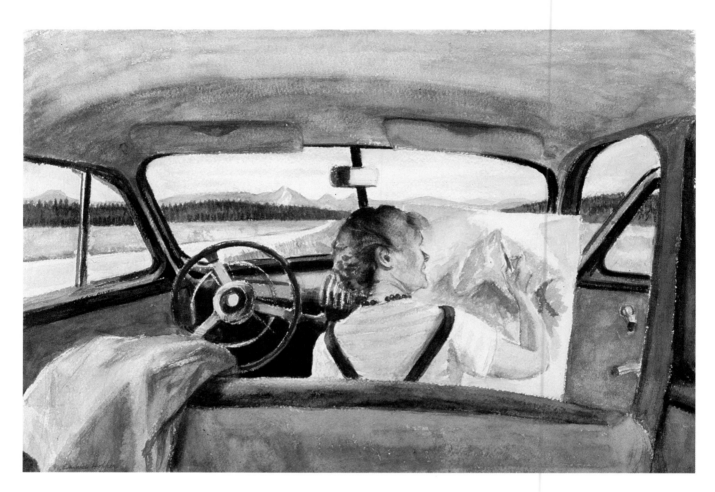

Jo in Wyoming

V. The Automobile and the American View

THE TOTAL NUMBER of car registrations almost tripled during the decade of the twenties. A total of over thirty-one million cars were sold, and more than four and a half million trucks were purchased. People bought cars on time, and for the first time in history they were able to buy houses, furniture, and stocks with only small down payments. Their purchases helped bolster a flagging economy, and the 1920s came to be viewed as a great time of optimism. The recently established child labor law helped to change attitudes toward children. In the 1920s more children attended school, and the summer vacation, characterized by a family piled into an automobile and prepared to tour America, became a commonplace. Edward and Jo Hopper became part of the group of automobile owners in 1927 when they purchased a Dodge. The term "Sunday driver," which described people out for a drive with no other purpose than to look at the scenery, came into use. Service stations and grease palaces were established to care for automobiles, roads were built to accommodate them, and tourist homes and motels were opened to house and care for the people driving them. Rural America changed radically in this decade: paved roads frequently paralleled railroad tracks, and telephone and electric wires accompanied the new roads, creating an image of the United States as one vast transportation network. Even though the roads and automobiles supposedly provided people with freedom, they also limited their experience. They might travel to New Mexico, California, and Maine, but their constant view was of roads, signs, telephone and electrical wires, and railroad tracks. Although one might see diverse landscapes, one viewed them from the car—one, in other words, saw them through a filter of man-made lines that restricted and limited vision.

Hopper's paintings are important documents of the incredible changes then sweeping the land; they are chronicles of new American attitudes toward the landscape; and they almost always present Janus-faced views that look both forward and backward at the same time. Hopper often puts viewers in the driver's seat and propels them into the future, and at the same time he provides elements of the past that can only be glanced

Jo in Wyoming

July 1946. Watercolor on paper, 14 × 20″
Whitney Museum of American Art, New York City
Josephine N. Hopper Bequest
70.1159

Hopper often approached the American landscape as a tourist rather than painting it in terms of its essences and dynamics. In Jo in Wyoming, *Hopper is more aware of the car, the road, and his wife sketching than he is of the mountains in the background.*

91

at casually. Frequently he focuses on those individuals who are not permitted to live the American dream and who must endure a nonhistoric past. Taken together these two types of images chronicle America's immersion in a constant present, its love affair with progress and speed, and its inability to provide relief for those people who are unable to participate in this frenetic dream.

New York, New Haven, and Hartford

1931. Oil on canvas, 32 × 50"
Indianapolis Museum of Art
Emma Harter Sweetser Fund

The subject of this painting is the glimpse of the landscape permitted a commuter en route.

Even before he purchased his car, Hopper began venturing out of his New England confines in the summer of 1925 to travel to James Mountain, Colorado, and Santa Fe, New Mexico. He was continuing in the footsteps of John Sloan, who found Santa Fe and its environs excellent subject matter. But when Hopper came to Santa Fe, he could not settle down to the comfortable existence of painting scenes only because they were beau-

Railroad Crossing

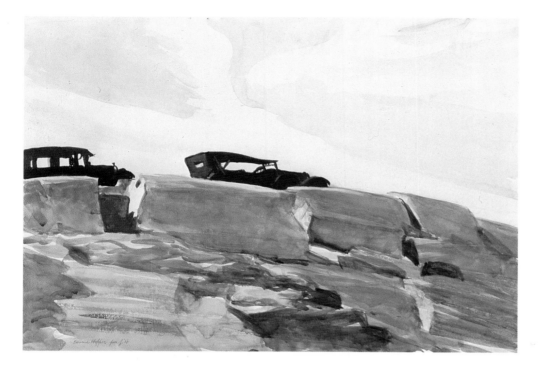

[Cars and Rocks]

1927. Watercolor on paper, 12⅞ × 19⅞"
Whitney Museum of American Art, New York City
Josephine N. Hopper Bequest
70.1104

This watercolor, like Jo in Wyoming, *is a study of an actual scene and reveals Hopper's direct approach toward the American landscape in his painting.*

tiful. According to Jo, he became frustrated, and was unable to paint until he found the right subject matter, in this case a train. From painting the train he moved to architecture and made watercolors of St. Michael's College, adobe houses, and St. Francis Tower in New Mexico. Although the watercolors of the southwestern buildings are superbly rendered, Hopper's image of a railroad trestle in the desert (1925) is more satisfying because it avoids the local color and illustrative quality of St. Michael's College, for example, and recasts the ubiquitous railway system in a new terrain providing continuity and new meaning to the earlier works *American Landscape* and *House by the Railroad.* The railway trestle is neither a hero nor a victim in the landscape; it is simply there. The demonstrative nature of Hopper's realism serves to question why this unnotable scene should be remarked on at all. One imagines a motorist saying, "Look over there." And of course everyone in the car looks and politely acknowledges the unmemorable railway trestle.

Hopper provides many such moments in his art. The watercolor *Railroad Crossing* (1926) is a similarly unimportant event that is remarkable for its ubiquity. Here the scene is even more clearly characterized as the point of view of the motorist since the observer is situated in the middle of a road, which is shown slightly out of focus to connote movement toward an intersection. Only the railroad track is in focus to indicate that driving reorients a person so that the landscape is viewed in terms of movement and obstacles. Similar scenes are repeated a number of times in Hopper's

Railroad Crossing

1926. Watercolor on paper, 13½ × 19½"
Private collection

In this watercolor Hopper emphasizes the new way the viewer approaches nature and the American scene: the point of view is that of a motorist.

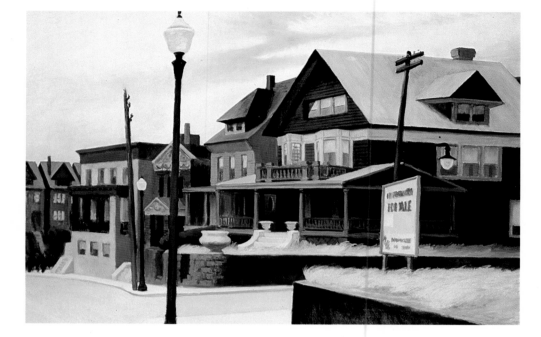

art. This orientation from the street is the actual subject of a number of works that appears on first examination to be about architecture. Some are *House with Fence* (1923), *Haskell's House* (1924), *Custom House Portland* (1927), *Adam's House* (1928), *Street Scene, Gloucester* (1934), *Captain Kelly's House* (1931), *East Wind Over Weehawken* (1934), *Solitude* (1944), *August in the City* (1945), and *Portrait of Orleans* (1950). In 1927 Hopper made a watercolor of cars perched above rocky cliffs to show that his landscape was not separate from the mode of transportation that provided him access to it. In 1945 he made drawings of a tourist home in Provincetown, Massachusetts, while seated in his car and then visited it regularly while converting his impressions into the painting *Rooms for Tourists,* choosing to remain in his vehicle while he looked at it. His reluctance to stand outside the tourist home may result from his shyness, but it also can be attributed to his interest in basing his point of view on that of a motorist who would stop in front of a tourist home and consider whether it would offer comfortable lodgings. In 1946 Hopper made the watercolor portrait *Jo in Wyoming,* which showed her seated in their automobile composing a picture of the mountains. His watercolor of her, made from the back seat of the car, reinforces the reality of the scene. He presents both of them as tourists, and he demonstrates that one's outlook is dependent on one's mode of travel. If one drives, then the views are all the predetermined scenes available to motorists: they may be grand, but they are always seen from the vantage point of an automobile.

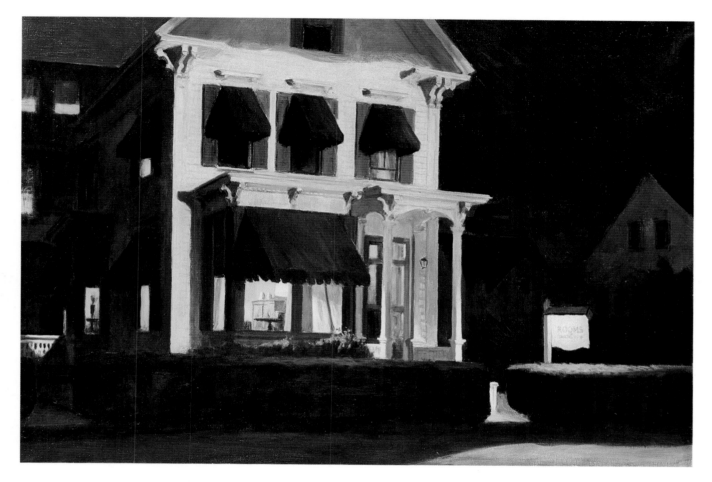

Rooms for Tourists

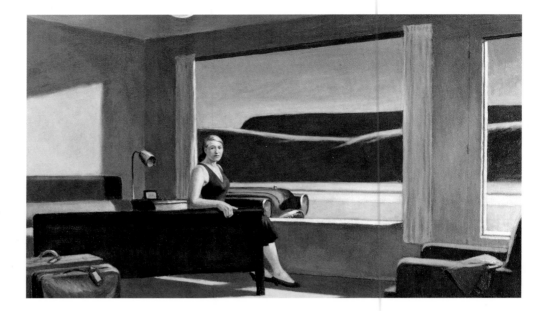

Western Motel

1957. Oil on canvas, 30¼ × 60⅛″
Yale University Art Gallery,
New Haven, Connecticut
Bequest of Stephen Carlton Clarke, B.A., 1903

The mountains here are generic; the real view is the motel room, the tourist, and the automobile. The picture window duplicates a major architectural device of 1950s suburban houses and thus provides the tourist with familiar surroundings that make traveling less of an adventure than an extension of one's own everyday world.

Street Scene, Gloucester

1934. Oil on canvas, 28 × 36″
The Cincinnati Art Museum, Ohio
The Edwin and Virginia Irwin Memorial

The watercolor on which this painting is based was made in 1928. The street and the sidewalk in both are more important than the row of houses because the orientation is that of a motorist.

Western Motel (1957) continues Hopper's concern with the automobile and the world it has helped to create. The painting situates the invisible viewer in a motel room looking at a woman who is posed on a bed and staring back at the viewer. Outside the picture window is an automobile that one supposes brought both her and the viewer to this spot. The two suitcases and the double bed suggest that the observer is also a registered guest of the room. The conjunction of a picture window with the self-conscious pose of the woman implies that the observer is in the act of taking a picture which will record the grandeur of the mountain scene and prove that the woman was there. The scene then is viewed through the amenities created for the typical tourist: car, motel, picture window, road, and camera.

When Hopper paints a situation such as *Western Motel,* which is obviously raw material for a snapshot, he confers on it a dignity and a meaning that go far beyond the actual circumstances of the picture. By making this anonymous motel room and nondescript western landscape the subject of a painting, he sets up comparisons with other scenes that artists believed significant enough or ubiquitous enough to memorialize in art. Hopper's *Western Motel,* for example, serves as a very mundane twentieth-century descendant of Albert Bierstadt's nineteenth-century majestic views. It reinforces the fact that the West has been domesticated and is now framed by a picture window that is an extension of the same kind of opening found on 1950s suburban tract houses. Although the generic mountains are exotic, the motel room is familiar to any suburban dweller. The paint-

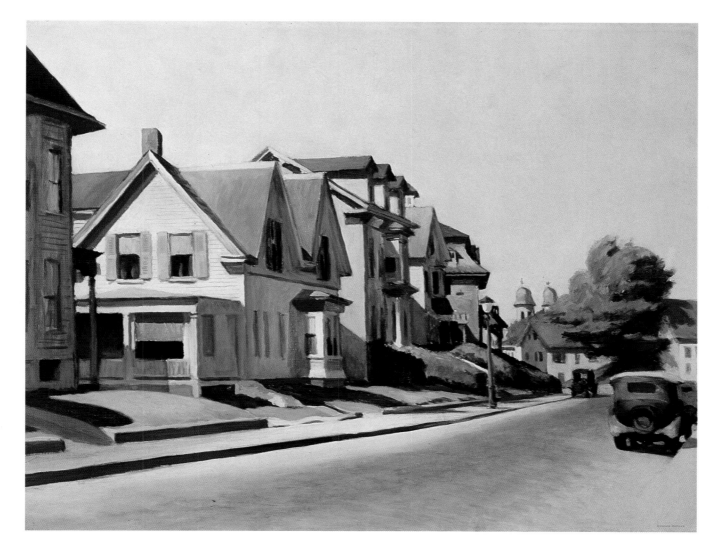

Street Scene, Gloucester

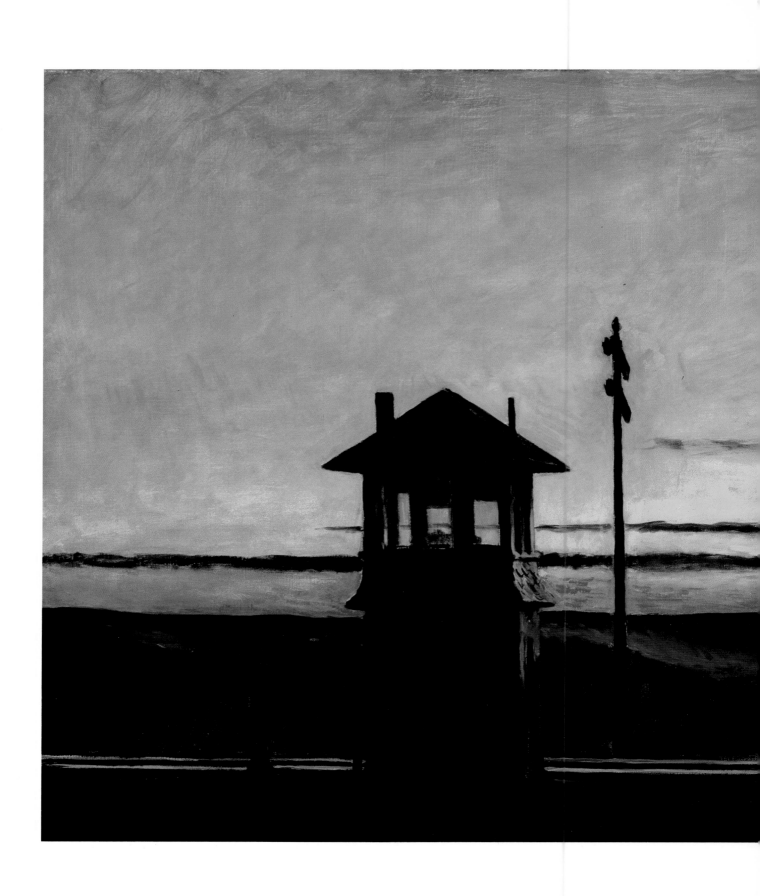

Railroad Sunset

1929. Oil on canvas, 28¼ × 47¾″
Whitney Museum of American Art, New York City
Josephine N. Hopper Bequest
70.1170

In this painting Hopper creates a familiar yet generalized view of America: he shows the railroad as a disruption of the land and the sunset as a possible symbol of the end of an era.

ing thus alludes to the fact that modern travel is often a collection of picture postcards and snapshots that lamely attempt to prove that one has gone outside the constraints of everyday life.

Western Motel connects Hopper to a generation of 1960s artists that includes Pop artists Andy Warhol and Claes Oldenburg *(Bedroom Ensemble)*, New Realists Richard Estes and Ralph Goings, and the Earth artist Robert Smithson. The case of Smithson is particularly interesting because he was fascinated by the nonspaces of the modern world, which he considered to be movie theaters, shopping centers, parking lots, art galleries, highways, and motels. Virginia Dwan, his dealer, has related his interest in motels:

You want to know what was most interesting about Bob? Well, I don't know. All I do know is that he had this—call it an uncanny ability to take the most mundane things and make them seem—well, make them seem fantastic and intensely exciting. Like the Golden Spike Motel, for example, that dumpy nowheresville kind of place with linoleum rugs and strange heaters up high on the wall. To Bob the Golden Spike was not just a dump, it was an adventure, a place of mystery, so strange and exciting one would swear he was in a science fiction world. He communicated this idea, he made those around him feel it, and I guess that's what was so exciting about Bob and his work. (Conversation with the author, January 1980)

Though Hopper's work was important for this younger generation, his orientation was different from theirs. Always in the back of his mind were nineteenth-century values that had been subverted in the twentieth century. In *Western Motel* he is concerned with the diminution of the Hudson River School's grandiose images of the American West—a concern that had led him earlier to create an image of a railroad track that separated the viewer from a glorious sunset in *Railroad Sunset* (1929)—while the younger generation of artists of the 1960s looked to mass-media advertising and film as points of departure. They were not so concerned with the loss of human values as they were with finding culturally based signs that defined the modern person. They believed that individuality was a construct, a capitalist product, and not an ideal state for humanity. In terms of its concern with the plight of the individual, *Western Motel* is much closer to Jack Kerouac's mad tale of cross-continental excursions in *On the Road*, which was published two years prior to the painting, even though the book deals with two reckless youths while the woman in Hopper's painting is obviously a member of the sedate middle class.

Western Motel could thus be considered a 1950s meditation on the meaning of the road in American culture and an affirmation of the standardization that has replaced local color and individuality. In earlier works Hopper had attempted to reflect on local color, but he quickly dis-

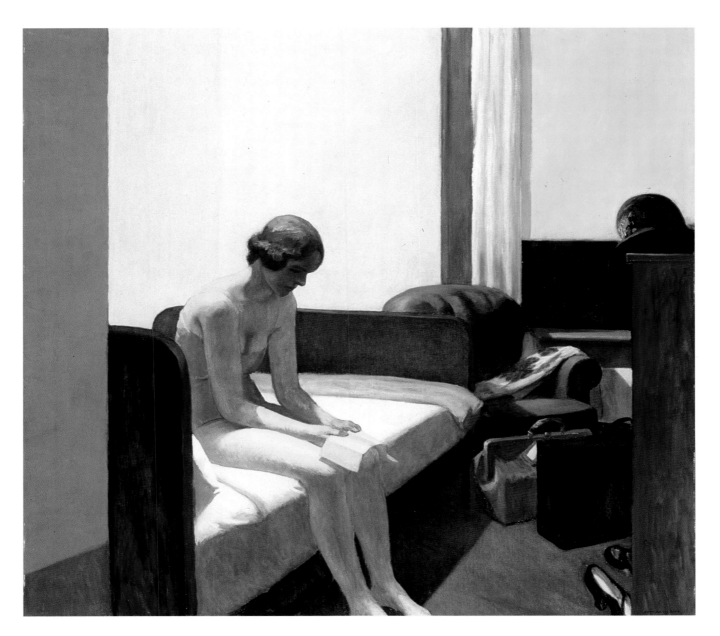

Hotel Room

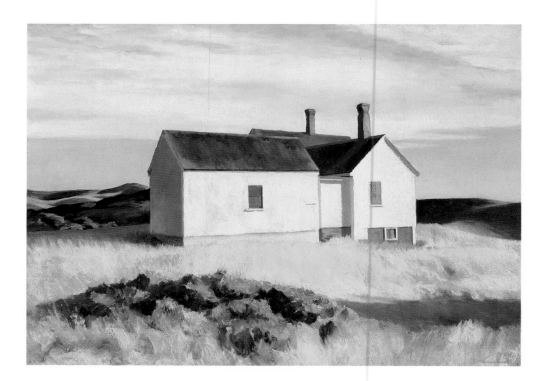

Ryder's House *is an unsentimental view of a victim of twentieth-century progress. The closed, nineteenth-century farmhouse is surrounded by an overgrown field. In this painting Hopper avoids any temptation to romanticize the scene in the manner of nineteenth-century art: bright sunlight in this picture blaringly points up the harsh reality of the abandoned farm.*

Although paintings of aging or unused barns are now regarded as nostalgic subjects for Sunday painters, Hopper's rendition of Cobb's barn is an original concept that deals with the difficulties of the Depression when farms throughout the country were abandoned. The painting conveys a special power because it does not allow the viewer to empathize with the farmer's loss. The viewer is choreographed as a casual interloper who takes pleasure in the stunning passages of sunlight and shadow, and looks at the overgrown weeds and deserted buildings as romantic additions to a picturesque scene. In this manner the viewer, who may be a motorist, is condemned because he or she is only looking at the land superficially and is unconcerned with recent changes. It is worth noting that Hopper was renting Burly Cobb's house at the time this picture was painted.

claimed alliances to American scene painting when he realized that paintings of unique areas frequently mediated the shock of the new and made America folksy and sentimental. Hopper attempted to escape the confines of illustration and remain a realist who was true to the alienating temper of his times. In the early 1930s he created a series of works that reflected his summers on Cape Cod and that dealt with the realities of the Depression. These works are particularly difficult to appreciate today because they have been copied many times over by artists who have created less trenchant and certainly sentimental versions of them. Hopper's paintings present the desolation and abandonment of farming on the Cape, and they make a poignant statement of the difficulties of the Depression. The farm population had declined in the 1920s from thirty-one million to thirty million and thirteen million acres of farmland had been abandoned in this same decade. If one can pare away all the clichéd images of old, unused barns and look anew at the paintings of Burly Cobb's house and barns in South Truro as well as Ryder's house, one can see that Hopper is memorializing a passing way of life. He presents the scene as viewed by a motorist who might be out on the Cape for the weekend. These paintings condemn the viewer who looks at them because they indicate a superficial view of the land: they offer stunning passages of sunlight and shadow and only hint at the personal tragedy that has befallen a farmer whose barnyard is overgrown with weeds and whose outbuildings are closed and deserted.

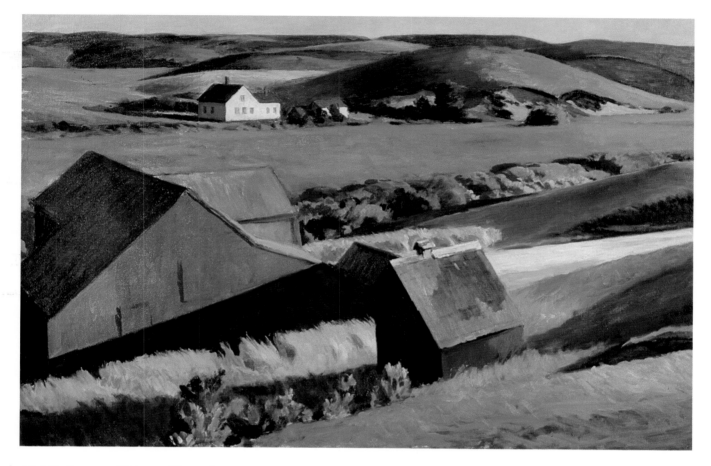

[Cobb's Barn and Distant Houses]

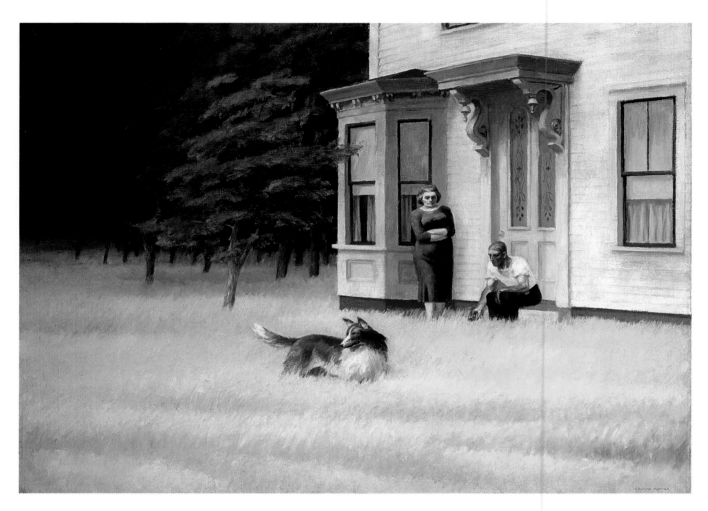

Cape Cod Evening

VI. Outside the Mainstream: The Victims of Modernism

Though Hopper's paintings of the Cape in the 1930s presuppose a casual viewer, they are not all seen from the vantage point of the motorist. *Cape Cod Afternoon* (1936) is a view of an abandoned house from the rear. It is one of the most desolate of Hopper's buildings and is unrelieved by any clue to a specific narrative. Hopper does not present any vestige of a road nor does he indicate why viewers should be located in the field behind this house, which he simply points to without comment.

Hopper's great culminating picture of Cape Cod in the 1930s is *Cape Cod Evening* (1939). In the ledger book, Jo notes:

> *Cape Cod Evening—finished July 30, 1939*
> *Note design on glass door and house. Young man . . .*
> *good looking Swede. Was to have been called "Whipporwill"*
> *[sic] Dog hears it. . . . Woman a Finn & dour. Trees in*
> *phalanx position, creeping up on one with the dar[k]. The*
> *Whipporwill [sic] is there out of sight. Painted in*
> *S. Truro Studio. (Vol. II)*

Lloyd Goodrich has quoted Hopper's own account of the painting:

It is no exact transcription of a place, but pieced together from sketches and mental impressions of things in the vicinity. The grove of locust trees was done from sketches nearby. The doorway of the house comes from Orleans about twenty miles from here. The figures were done almost entirely without models, and the dry, blowing grass can be seen from my studio window in the late summer or autumn. In the woman I attempted to get the broad, strong-jawed face and blond hair of a Finnish type of which there are many on the Cape. The man is a dark-haired Yankee. The dog is listening to something, probably a whippoorwill or some evening sound.

Several aspects of both descriptions need to be elaborated on: (1) the scene is late summer or autumn, (2) the couple is of immigrant stock or a

Cape Cod Evening

1939. Oil on canvas, 30¼ × 40¼″
National Gallery of Art,
Washington, D.C.
John Hay Whitney Collection

In his art Hopper reflected on progress, its beneficiaries and its victims. In this painting the couple belongs to the latter group. Their yard has become a field that is in the process of being overrun by locust trees, and the couple huddles near a grand house that seems alien to them—a house that belongs to another era and bespeaks a refinement that is inconsistent with their work-worn appearance.

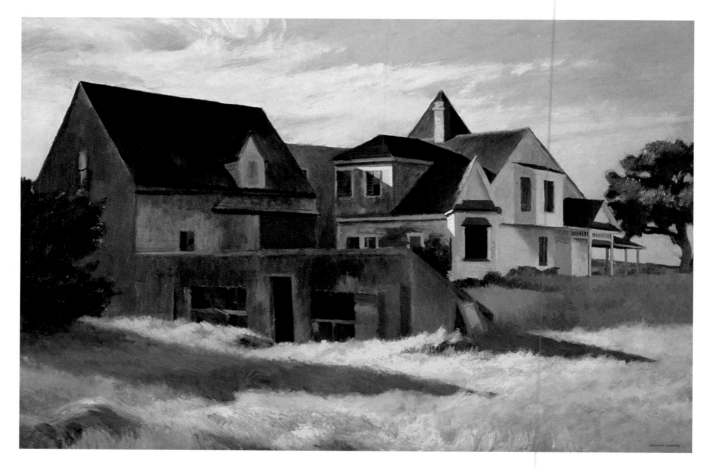

Cape Cod Afternoon

mixture of immigrant (the man who may be Swedish and the woman who is definitely Finnish) and local (the man whom Edward Hopper refers to as "Yankee"), (3) the dog responds to the sound of the whippoorwill outside the painting, and (4) nature is once again taking over: the trees are regarded as a phalanx, and night is approaching.

Cape Cod Evening is concerned with the loss of a viable rural America: it focuses on those people and places that have been left in the wake of progress. Today it is rarely remembered how enormous were the differences between the rural and urban population in the late 1930s. At that time three out of every four farms were lit by kerosene lamps, a quarter of the rural homes lacked running water, and a third were without flush toilets. *Cape Cod Evening* was created the same year as the New York World's Fair, which was entitled The World of Tomorrow. The fair featured a robot called Elektro, which could talk and smoke, and an exhibit organized by GM entitled Futurama. Designed by Norman Bel Geddes, the GM exhibition drew twenty-eight thousand paying customers a day who sat on a conveyor belt armchair for fifteen minutes and listened to a recorded voice explaining what the American landscape would be like in 1960. To a generation that had been burdened by the Depression, Bel Geddes's predictions were less important for their accurate forecasting than for the fact that he was offering people an opportunity to begin thinking optimistically about the future.

In *Cape Cod Evening* Hopper creates a complete contrast to The World of Tomorrow by picturing a future that is retrograde. He shows how nature is reclaiming land, which less than a century before had been domesticated into the site of an imposing Victorian house with its attendant garden. Although the collie in the preliminary drawing for this painting is turned toward the couple, in the completed painting it directs its attention to the sound of the whippoorwill, which symbolizes the power of nature over culture. The Victorian house is shown standing in a field of grass; it has lost its lawn, and locust trees have advanced to the house and are in the process of taking over. The woman appears uncomfortable in the grass. Dressed in a modish streamlined style, which is inappropriate for her very full figure, she is a composite of misaligned signs. Her Rubensian figure might have made her a candidate for a fertile earth mother in another era, but in the 1930s she symbolizes nature overgrown and ill at ease with itself, nature corseted and wearing bobbed hair. The onlooker of this scene is probably a local who is familiar with the lay of the land, a person who would note that the trees are locust and who thus differs from Hopper's usual observer, the motorist from a metropolitan area who regards all flora and fauna generically. The change in orientation is indicative of Hopper's own situation, for he had built a place in South Truro in

Cape Cod Afternoon

1936. Oil on canvas, 34¼ × 50″
The Carnegie Museum of Art, Pittsburgh
Patrons Art Fund, 1938

Cape Cod Afternoon *pictures the desolation and ruin of an abandoned farmhouse in the midst of the Depression.*

David Johnson
Old Mill, West Milford, New Jersey

1850. Oil on canvas, 17 × 23"
The Brooklyn Museum, 08.223
Gift of Peter A. Leman

David Johnson's old mill pond is a romantic reflection on an early victim of industrialization. Unlike Hopper's paintings, the weeds are lovingly characterized as to their individual species, and the dam and rocks are as beautifully and carefully portrayed as the ancient Greek and Roman ruins artists were then memorializing.

1934 and spent six months out of almost every succeeding year of the rest of his life on the Cape. His new orientation made him increasingly alert to the problems of people in the country who frequently did not have basic modern amenities and who were suffering from a sustained economic depression that extended years beyond the Great Depression.

Cape Cod Evening constitutes a new paradigm in American landscape painting, for it emphasizes the passing of the agrarian age and the forlorn individuals who become idle caretakers of an anachronistic way of life. While *Early Sunday Morning* permits a positive reading of the role of the small businessperson in reorienting the economy of the United States, *Cape Cod Evening* does not allow any such approach. The couple seen in this painting could inhabit *House by the Railroad.* The difference between both pictures is that the conflict is no longer between new modes of transportation and old-world culture: the conflict is between obsolete life-styles and nature. This theme had been briefly presented in American art in the 1860s when abandoned mills were viewed as romantic ruins by David Johnson. But his pictures do not constitute the new paradigm represented by *Cape Cod Evening* because they become suffused in nostalgia and in a delight in history that is affirmative and that differs from the pessimism of Hopper, who pictures a forlorn couple out-of-character with its grandiose Victorian house and intimated by the unruly nature outside. The importance of this picture and Hopper's other Cape Cod scenes can be gauged by the fact that they served as influences for many paintings by Andrew Wyeth, particularly his series of works on the Kuerners and the Olsons. The couple of *Cape Cod Evening* could be considered a source for Christina and Alvaro Olson, and the house a basis for the paintings *Christina's World* and *Weather Side.*

The same year Hopper painted *Cape Cod Evening* he created *New York Movie* (1939), which is also concerned with the victims of progress. In the ledger book, Jo marvels at the number of light sources in the picture—"4 sources: bracket with three lights, right wall, light inside staircase R, light from lamps underside of boxes, L., & light from screen"—and the interest in artificial lighting does provide a basis for this painting, which dramatizes an important nonspace of the twentieth century. In spite of the opulence of this theater, none of the people pictured in it is looking at it. The usherette's eyes are closed, and the two spectators who are isolated from each other are watching the black-and-white image on the screen, which becomes abstract and removed from life in this painting. The function of the movie house is to comfort the audience by providing them with self-conscious symbols of traditional opulence and thereby letting them relax in a simulation of a grandiose past where they can feel secure as they watch visions of the present in the form of the movie. The people in this painting

Édouard Manet
A Bar at the Folies-Bergère

1882. Oil on canvas, 37½ × 51″
Courtauld Institute of Art, London

Manet's haunting image of a lonely wait-ress in the midst of gaiety has affinities with the daydreaming usherette in Hop-per's New York Movie.

are victims of progress because they are isolated from each other and in-volved in the vicarious experiences provided by the movie or their day-dreams, in the case of the usherette. Only the assumed observer of this painting takes in the entire scene, and this viewer is characterized as some-one who has gotten out of his or her chair and is preparing to leave. (Note: if this person were entering the theater, the usherette would no doubt take notice.) The entire painting, then, is concerned with leavetaking, with seeming to be sated with a wealth of illusions that includes the film and the building, and with allowing this artificial world to lull one into thinking that life is not alienating and that the modern world is wonderful because it provides larger-than-life experiences in the theater. The usherette who is caught up in her own daydreams and the isolated spectators, however, point up the hollowness of this sumptuous and action-filled world. The usherette is a twentieth-century counterpart to the bored waitress in Ma-net's *A Bar at the Folies-Bergères.* Similar to Manet, Hopper has a genius for making the illusory world of the theater so enticing, so glamorous, and so completely empty. He tantalizes his assumed viewer with an almost mysti-cal apricot light that illuminates the steps that lead out of this unreal world where the usherette stands guard. Since movies were enormously popular in the 1930s—the average family spent twenty-five dollars a year on them in the midst of the Depression, eighty-five million Americans attended them annually, and the approximately seventeen thousand theaters in the country each year showed up to four hundred films—one can assume that

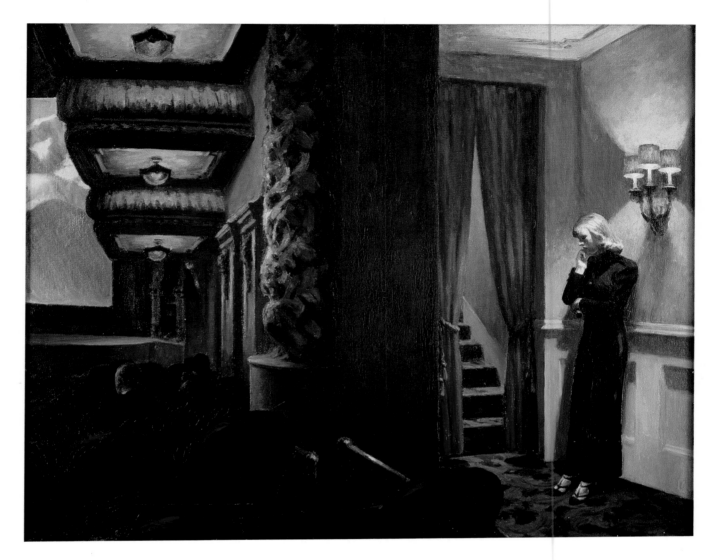

New York Movie

the few patrons attending the film in Hopper's *New York Movie* are watching it on an off-hour, most likely in the afternoon. The scarcity of the audience indicative of an off-hour screening emphasizes the feelings of alienation and loneliness that this painting conveys. And the time of day alluded to poses a question for the viewer, who must ultimately ask what he or she is doing in the theater at this hour.

By the mid-1920s Edward Hopper had established his mature style, and by the late thirties he had plumbed this style so thoroughly that it presented modern life as a mad rush to the future and also an intolerable long wait for those outside the mainstream. Being sympathetic with Progressivism, Hopper at first understood progress as a return to the early nineteenth-century concept of the individual who is a small-time entrepreneur unencumbered by big business. And he tried to hold on to this idea until he moved to the Cape and discovered the problems farmers were encountering. His discovery resulted in paintings of Burly Cobb's farm and such pictures as *Cape Cod Evening*. Recognizing that there is no ideal situation in the modern world made his realism even more trenchant because he could no longer use Progressivism as a standard for judging change. In the last two-and-a-half decades of his life, Hopper developed themes begun in the twenties and thirties, and he continued to be intrigued with the changing face of America. He pursued his interest in the modern viewer's role and created works aimed at the stage set constituting his paintings and directed as well to the offstage viewer whose orientation formed the basis for distinctly felt reactions to the material presented. Hopper's realism, then, remains as focused on what is seen as it is concerned with the person who is looking. He went to movies and to plays and amalgamated aspects of the two, as well as his own point of view, in his art.

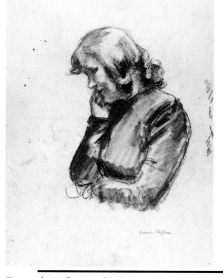

Drawing for painting *New York Movie*

1939. Conté on paper, 15 × 11⅛"
Whitney Museum of American Art, New York City
Josephine N. Hopper Bequest

In spite of her age, Jo served as a model for the young usherette in New York Movie. *The studies of Jo assuming various roles indicate Edward's regard for his art as repertory theater and his wife as a prized actress.*

New York Movie

1939. Oil on canvas, 32¼ × 40⅛"
Collection, The Museum of Modern Art,
New York City
Given anonymously

The people in this painting are isolated from each other and are involved in vicarious experiences provided by the movie or—in the case of the usherette—their own daydreams.

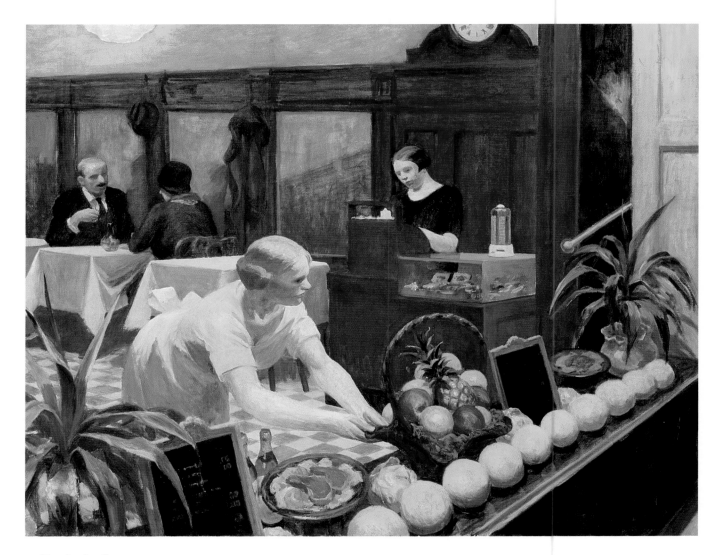

Tables for Ladies

VII. Late Works: 1940–1965

ALTHOUGH HOPPER held to certain working premises that are involved with his attitudes toward light, color, and composition, he rarely resorted to a formula. The exceptions are his watercolors, which were usually made on the spot. When Hopper made the one, two, and, more rarely, three oil paintings per year that constituted his most searching work, he allowed a range of impressions to become distilled into one subject that served as an icon of modern life. On occasion these paintings could be related to specific current events, but more often the works captured the mood of a particular time and indirectly alluded to current affairs. Hopper deals more with general drifts of human feeling than with particular moments; he catches hold of the ambience of change and the mood of a period.

Although Hopper appears to continue the strict mathematical configuration of Italian Renaissance perspective, he at times plays with space to create subtly jarring environments that underscore the fact that modern life is not as balanced or rational as it might appear. Whereas the Renaissance artists Perugino, Leonardo, Michelangelo, and Raphael were looking for ways to create space so that it would manifest a balance and harmony among contemporary humanists, classical architecture, and the world around them, Hopper was attempting to find realistic equivalences for his subjective understanding of the world.

In *Office at Night,* for example, Hopper plays with Renaissance perspective to attain an altogether new effect. The side walls of the office are not parallel—they have been slightly skewed—and the floor buckles under the weight of the man's desk forming an incline on the left and an upward movement on the right. The liberties taken with this area put the viewer's space in jeopardy. The viewer seems to occupy a place on the adjacent side of the office and appears to be looking down at the scene, but the change in scale between the secretary's table, the man's desk, and the woman standing in front of the file cabinet are all slightly off. This lack of balance and proportion within the painting sets up tensions that are then communicated to the viewer who seems to be unable to become part of this

Tables for Ladies

1930. Oil on canvas, 48¼ × 60¼"
The Metropolitan Museum of Art, New York City
George A. Hearn Fund, 1931

The invisible viewer of this painting is placed outside the restaurant and looks in at the display of food and the tables. Placing the viewer outside the window might well refer to the gulf between the employed and the destitute that occurred at the time this painting was made—during the Great Depression.

115

seemingly ordinary scene of two people working in an office at night.

In this painting Hopper offers more clues to a narrative than he ordinarily does. To the left of the desk is a piece of paper that the woman has just seen. One assumes that when this voluptuous female reaches for the paper, her action will arouse the man. On the back wall Hopper has painted a section of artificial light, which in turn dramatizes the point where the man and woman will interact with each other. And the observer, whose orientation is acknowledged in the point of view of the painting, becomes an uneasy accomplice.

Office at Night characterizes the locked-out generation that came to maturity in the 1930s and found the economy unable to take advantage of its skills. In 1940 this situation changed when the United States began to prosper as a result of the Fortress America campaign that encouraged Congress to supply armaments to European powers fighting the Nazis. The locked-out generation had been accustomed to struggling for whatever it had: undergraduate students in the 1930s frequently worked forty hours a week to support their schooling and eighty hours a week during vacation. This generation was industrious and repressed—its most flamboyant girlie magazine, *The Stocking Parade,* for example, contained photographs of fully dressed young women with their skirts raised five or six inches above the knee, and maternity clothes in the 1930s were designed to "keep your secret." Hopper's *Office at Night,* then, captures both the repression of this generation and its vulnerability.

In the 1940s the United States experienced radical transformations due to the war, the increase in employment and prosperity, and the creation of a generation gap that developed out of child labor laws established a generation earlier, which had resulted in increased leisure time. In this decade swing music came of age and with it relaxed morals and attitudes that separated it from the generation of the 1930s. The change from the 1930s to the 1940s is heralded in a number of Hopper's paintings, as is the continuing saga of the first generation modernists who came of age in the 1920s.

In many works of the 1940s Hopper continued to paint the first-generation modernists and to find new roles for them. The aging stripper of *Girlie Show* (1941), for example, could be the bored girl of *Eleven A.M.* twenty years later. Of course, since Hopper used Jo as a model for all his females, the similarity may result from the fact that all women in his art were Jo. However, the couple in *Two on the Aisle* (1927) looks like the same people having lunch in *Tables for Ladies* (1930), as well as the man at the petroleum tank in *Gas* (1940), and possibly even the same couple, old and forlorn, in *Hotel by a Railroad* (1952). By taking people of the 1920s and showing their changing circumstances as they grew older, Hopper was

Two on the Aisle

1927. Oil on canvas, 40¼ × 48¼"
The Toledo Museum of Art
Gift of Edward Drummond Libbey

This scene contrasts sharply with the convivial images of the theater created by the French Impressionists. In spite of the theatergoers' festive dress, the event appears routine and unexciting. The painting focuses on the people rather than the stage and on the assumed viewer in the auditorium who is simply looking and waiting.

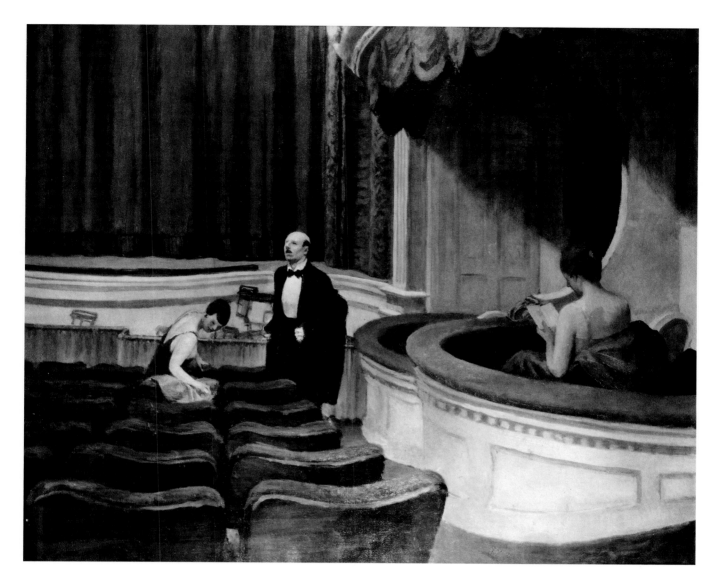

Two on the Aisle

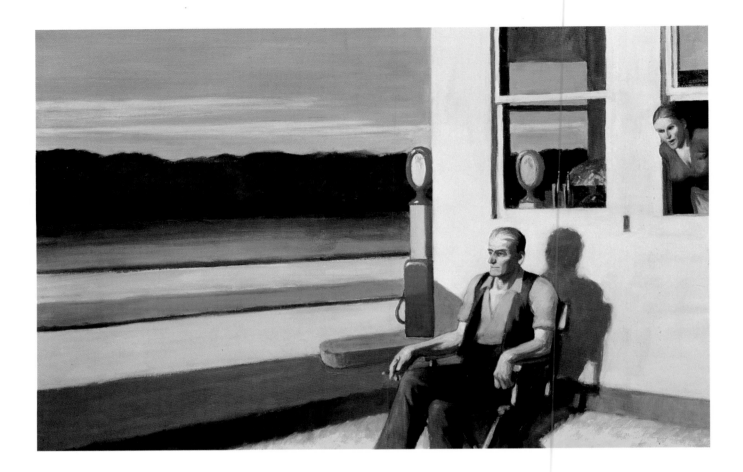

Four Lane Road

1956. Oil on canvas, $27\frac{1}{2} \times 41\frac{1}{2}''$
Private collection

Hopper's Four Lane Road *is a 1950s pendant to his earlier painting* Gas. *It demonstrates his interest in critiquing the cult of progress and showing people like this couple, who are left on its periphery.*

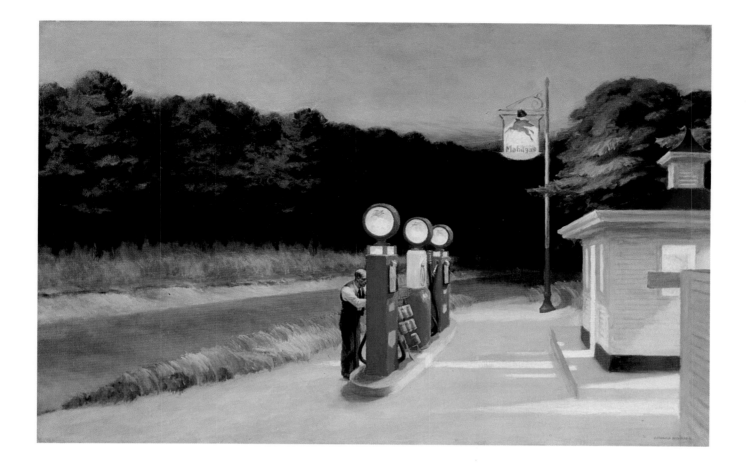

Gas

1940. Oil on canvas, 26¼ × 40¼″
Collection, The Museum of Modern Art,
New York City
Mrs. Simon Guggenheim Fund

Situated on a lonely country road, the Mobil gas station indicates the extent to which the automobile was invading all of America.

Caricature of "Non-Anger man" and "Pro-Anger woman"

c. 1925–35. Charcoal and pencil on yellow paper, 8½ × 5½″
Private collection

Although Edward and Jo's relationship was checkered, Edward reserved his criticism for private rather than public works of art and for incidental cartoons rather than for serious drawings and paintings. Jo may have been quarrelsome, petulant, and, in general, difficult, as many of the Hoppers' acquaintances have attested, but Edward portrayed her sympathetically in the many paintings and drawings he created over the years.

Approaching a City

1946. Oil on canvas, 27⅛ × 36″
The Phillips Collection, Washington, D.C.

The anonymity of the American city is one of Hopper's most important subjects.

able to present a convincing history of the modern age and to show how modernism itself had grown old, weary, abject, and bankrupt.

The repertory theatrical company is an organizing principle for Edward Hopper, who used his wife as the basis for all the women occurring in his art after their marriage. A loner, Hopper had few associations and almost no close friends except for his former classmate Guy Pène du Bois, a stylish Art Deco painter noted for his streamlined renditions of the human figure. In a 1931 article for *Creative Art,* Du Bois characterized his friend: "He is a quiet, retiring, restrained man who has been working for a number of years in New York and Paris, almost as a hermit, rarely exhibiting and rarely appearing in those places where artists gather, though known by and knowing most of them."

Hopper's life revolved almost entirely around his art and his wife, Jo. Stubborn and taciturn to the extreme, Hopper made of his small world a universe, and he managed to transform the one woman in his life into all women. His restricted world may have resulted from Jo's protectiveness as well as her attempt to dominate him and the few people with whom he associated. Jo was garrulous, petty, argumentative, and also fiercely loyal to Edward. Though she might consistently disagree with him, she had tremendous respect for his art, and helped to manage his world so that he could have the solitude and time to create. Edward may have been quiet, but he was not docile. He created his own personal world as he had created his art. The number of sensitive, intimate portraits that he made of Jo over the years points to his deep involvement and respect for her. In the 1920s he made several sensuous nude studies of her, and in the ensuing decades he created drawings and paintings that emphasized her emotional maturity and strength of will. These works could represent wishful thinking on his part, since they indicate a person far different from the constantly bickering, jealous female who is remembered by people acquainted with the Hoppers. In cartoons and casual sketches, however, Hopper indicates an understanding of his wife's failings, but he does not judge them significant enough for his serious art. These cartoons are caustic and funny: they point to Jo's imperiousness, her devotion to her cat who at times appears more important to her than Edward, and her lack of interest in preparing meals. Hopper's ability to make fun of Jo and himself indicates his confidence in their relationship.

It is difficult to fathom the human needs and satisfactions that are part of any marriage, and the Jo and Edward Hopper relationship is no exception. One can only wonder why Edward chose to transform his middle-aged wife into an oversexed secretary and an aging stripper in the 1940s. Was he so removed from life that Jo became a necessary intermediary? Was he so repressed that he could only fantasize about other wom-

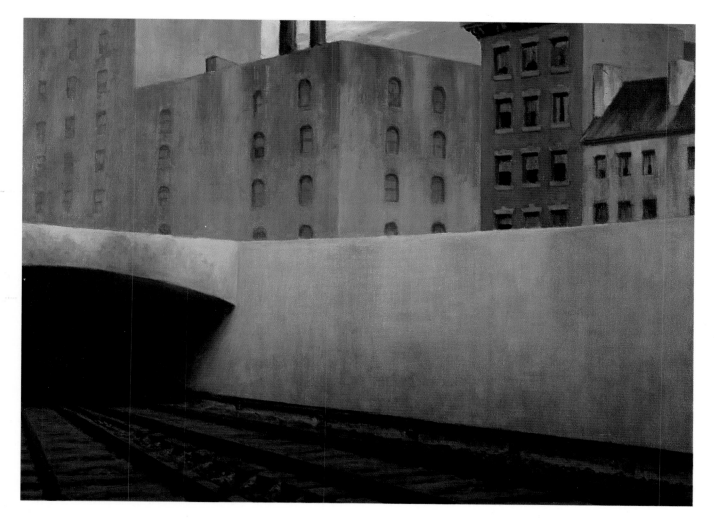

Approaching a City

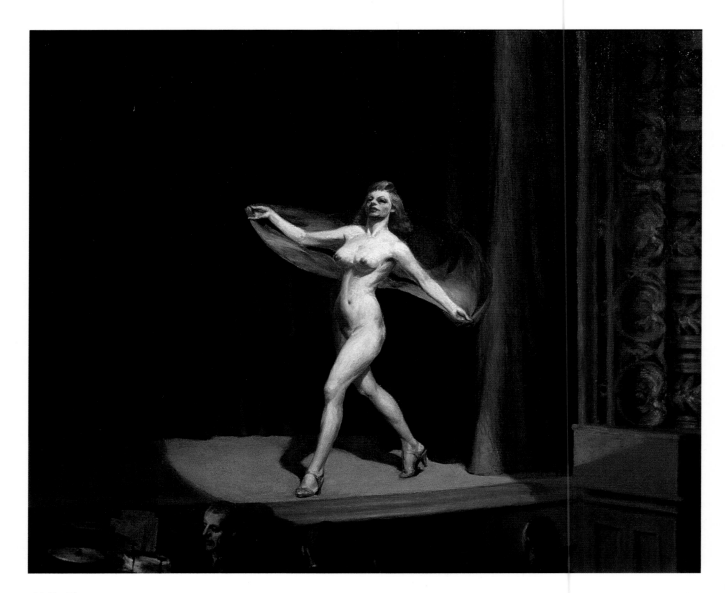

Girlie Show

en by first imagining Jo in these guises, or was he really so dominated by Jo that he could not hire young models if he wished? There does not seem to be any easy or clear answer to this aspect of Hopper's personal world, except to point to his portraits of Jo and suggest that theirs was a complex, intimate relationship that Edward regarded at times as immensely satisfying. Although he was a loner, he may not have been sexually repressed. His taciturnity made him appear glum and even monklike as Raphael Soyer recounted in a 1980 Edward Hopper symposium held at the Whitney Museum of American Art in New York City. Talking about a portrait that he made of Hopper for his *Homage to Thomas Eakins,* 1964–65, Soyer quoted a page from his own diary of 1963:

Carved and bent though his body is, his height [6 feet 4⅝ inches] comes through. I imagined him in the role of those fantastic saints who flagellate themselves or meditate in deserts in the paintings of Carpaccio and De la Tour. There is a loneliness about him, an habitual moroseness, a sadness to the point of anger. His voice breaks the silence loudly and sepulchrally. He posed still with folded hands on the table. A few times he raised his folded hands and scratched his ear with the tip of one of his intertwined fingers. We hardly conversed.

Hopper appears to have exhibited a healthy appreciation for the female body throughout his life and to have made it alluring even when it is middle-aged. As he moved away from the 1920s, he ceased to conceive the human form in smooth, thinly applied paint. His later figures are awkwardly modeled in thick paint. The new orientation cannot be written off as lack of skill but has to be considered a symbol for the human condition, for the body which has been described since before biblical times as an earth vessel.

Hopper's use of Jo as an actress from repertory theater, who is capable of playing many different roles, is consistent with his overall approach to art, his interest in creating new roles for the audience, and his practice of picturing isolated fragments that point as much to the function of the viewer as to the narrative content that is implied but not given. Jo helps Edward to extend his world even though he isolates each new scene by making his characters into general types instead of known individuals. Hopper becomes the implied viewer of his art, and then he questions his motives for looking at the scene and his connection to these isolated fragments of reality. He presents vision as a form of aggression, and he casts in doubt the artist's act of appropriating reality. He indicates that an artist can only take possession of fragments of reality and can never grasp it in its entirety; truth in his art is constantly changing, constantly open to new interpretations depending on who is viewing a scene. Looking at Hopper's

Drawing for painting *Girlie Show*

1941. Conté on paper, 22⅛ × 15"
Whitney Museum of American Art, New York City
Josephine N. Hopper Bequest
70.301

After the Hoppers' marriage, Jo served as the model for all the women depicted in Edward's art. Although she complained about the hours spent modeling, Jo seems to have been a willing subject. Whether she insisted on being involved in his art or whether Edward used her as his only model because she was available and he was shy about using others has been debated. Theirs was a complex relationship, a fact attested to by this nude drawing of Jo, who was at the time middle-aged.

Girlie Show

1941. Oil on canvas, 32 × 38"
Private collection

Hopper creates a number of situations and locations in his paintings familiar to the traveling salesman, among them hotel lobbies, tourist homes, motels, diners, and strip shows. Girlie Show *depicts the latter with this image of an aging stripper center stage.*

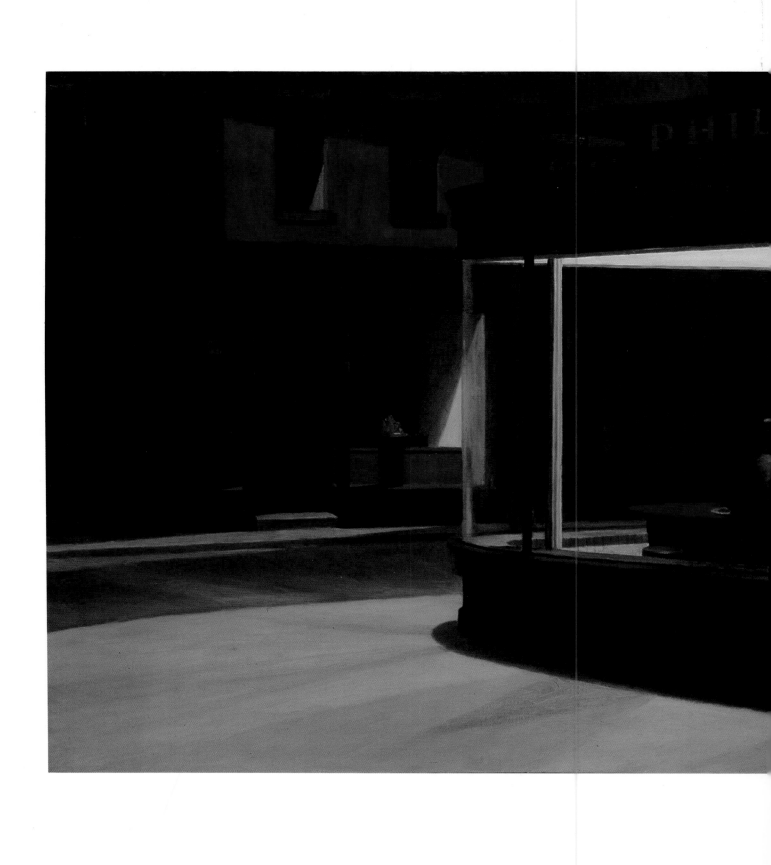

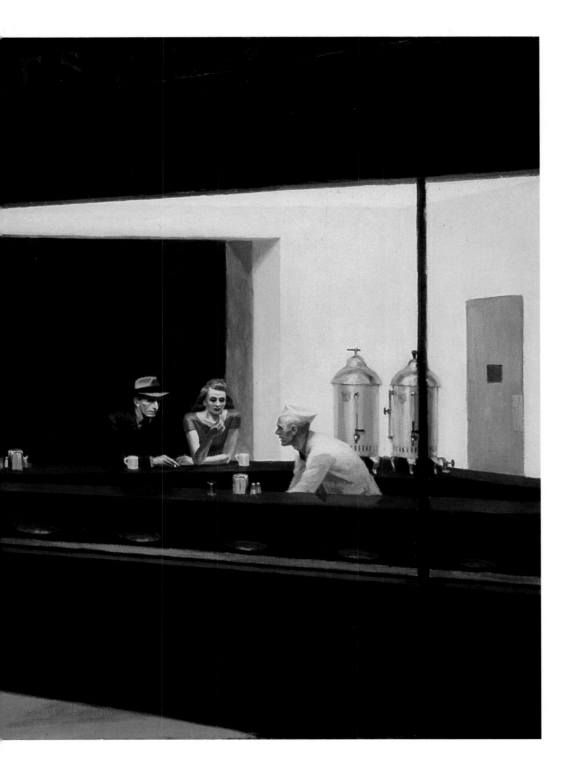

Nighthawks

1942. Oil on canvas, 33¼ × 60⅛″
The Art Institute of Chicago
Friends of American Art

In contrast to the old-fashioned stores in the background, the diner is lit with fluorescent lights, which had only come into use in the early 1940s. Circular in form, the diner is an island that beckons and repels; and the fluorescent lighting is intimidating, alienating, and ultimately dehumanizing.

[Reclining Nude]

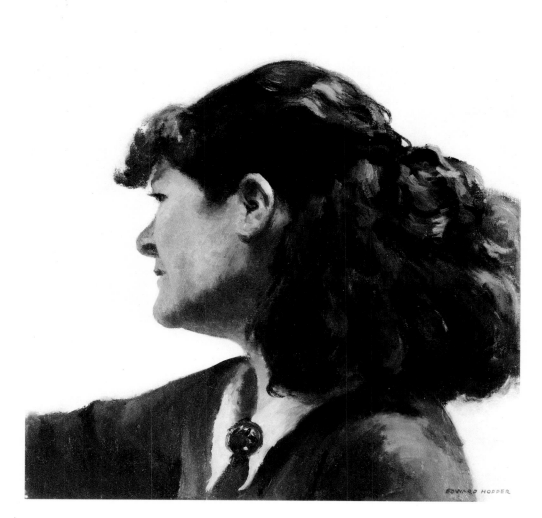

art is akin to voyeurism, to a type of seeing that is aggressive and passive, intimate and distant, sexually stimulating and safe. It is apparent that Hopper was a viewer of twentieth-century life and not a participant in it. He found a refuge for himself in his studio on Washington Square, which he left only for short vacations or for his other refuge on Cape Cod. And he found in Jo a constant companion and a model capable of becoming the many different women in his art. It is significant that the actual portraits of Jo are always intimate pictures of a distinct individual, while the fantasies are usually pictures of strangers: a voluptuous secretary, a female in a restaurant, an aging strip-tease artist, a young girl on a sidewalk, a sunbather.

Hopper's repertory of women can be categorized as diversions for travelers, and in particular for traveling salesmen, who are implied viewers of pictures dealing with the hotel lobby, the diner, the movie theater,

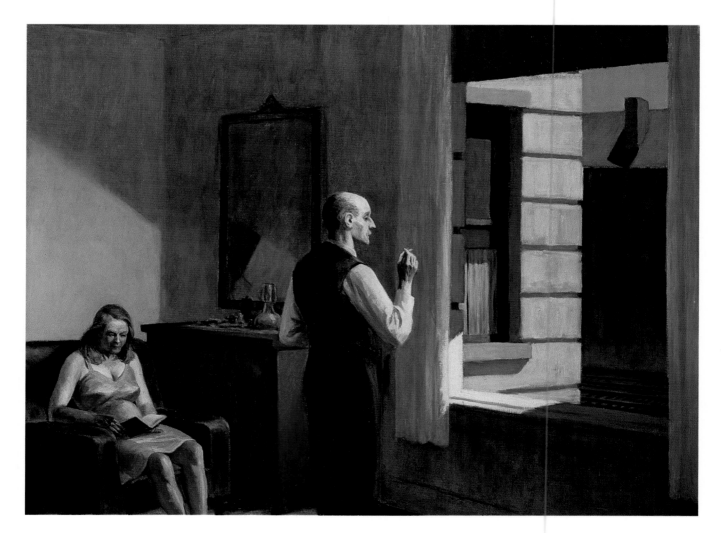

Hotel by a Railroad

and the burlesque hall. Both *Eleven A.M.* and *Girlie Show* can be considered part of this repertoire of images appealing to the traveling salesman, who is the twentieth-century counterpart of the nineteenth-century woodsman, cowboy, and trapper.

Nighthawks (1942), a picture of a diner at night, continues Hopper's concern with small-time businesses that was first established in *Early Sunday Morning.* The background of *Nighthawks,* in fact, consists of a row of stores that resembles those pictured in *Early Sunday Morning.* This background serves the psychological function of emphasizing the coldness of the diner in *Nighthawks.* The customers seated around the counter do not seem to be the kind of people who would operate the businesses on the opposite side of the street. The old-fashioned cash register seen in one of the dimly lit shops conjures up an air of familiarity and affability; it suggests a family business that has been in operation for a number of years and has been successful enough not to feel the need to modernize the store in order to keep customers. In contrast to the stores, the diner is lit with the new fluorescent lights that had only come in use in the early 1940s. Circular in form, this building is an island that beckons and repels; and the fluorescent lighting is intimidating, alienating, and dehumanizing. It creates an unreal and artificial feeling of warmth, an atmosphere that is clinical and more in tune with a laboratory than a restaurant. In conversation with Katherine Kuh, Hopper reflected that the scene for the painting "was suggested by a restaurant on Greenwich Avenue where two streets meet." He said, "I simplified the scene a great deal and made the restaurant bigger. Unconsciously, probably, I was painting the loneliness of a large city." Jo's entry in the ledger provides insight into the meaning of the diner and the people stationed within it:

Nighthawks—*night & brilliant interior of cheap restaurant. . . . Cherry wood counters & tops of surrounding stools, lights on metal tanks at rear right; brilliant streak of jade green tiles ¾ across canvas at base of glass. . . . Very good looking blond boy in white (coat, cap) inside counter. Girl in red blous[e], brown hair eating sandwich. Man nighthawk (beak) in dark suit, steel grey hat, black band, blue shirt (clean) holding cigarette. Other figure dark sinister back—at left. . . . Darkish old red brick houses opposite. Sign across top of restaurant shop dark—Phillies 5¢ cigar—picture of cigar.* (Vol. II)

When one looks closely at the heads of the man and woman facing the viewer, their faces are amazingly hawklike. The title *Nighthawks* can refer to people who are night owls, but it also refers to a particular kind of nocturnal bird (genus *Chordeiles*), which is related to goatsuckers and whippoorwills. The relationship of the nighthawk to the whippoorwills

Jo

n.d. Conté on paper, 18 × 15½"
Whitney Museum of American Art, New York City
Josephine N. Hopper Bequest
70.335

This thoroughly sympathetic portrait may represent an idealized Jo or else a woman who let down her guard only when she and Edward were alone. Fiercely loyal, Jo frequently badgered guests and her husband in her misguided efforts to protect him and his art.

Hotel by a Railroad

1952. Oil on canvas, 31¾ × 40⅛"
Hirshhorn Museum and Sculpture Garden,
Smithsonian Institution, Washington, D.C.

Hopper chronicled the generation of the 1920s and followed them through the ensuing decades of the twentieth century. The couple in this desolate hotel could be the same couple pictured in Two on the Aisle *and* Tables for Ladies. *The man also resembles the figure in* Gas. *By inventing a cast of characters and using it in paintings that span several decades, Hopper was able to dramatize the emptiness of modernism and the problems of growing old in a world that places a high premium on youth.*

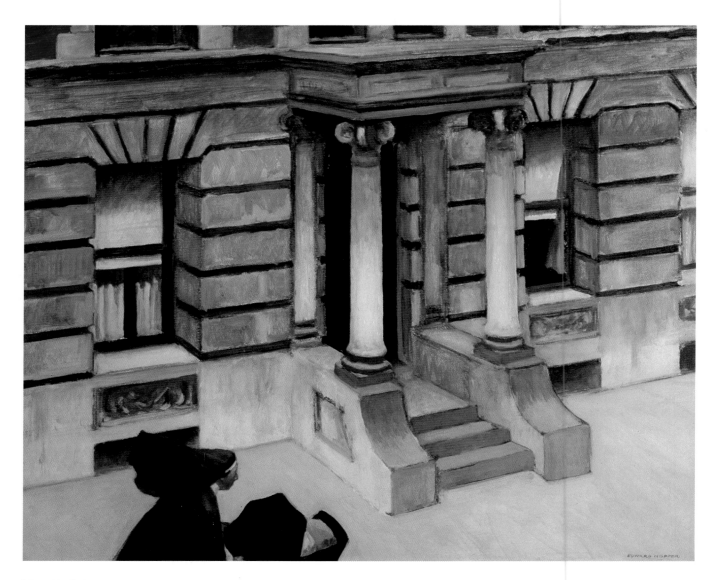

New York Pavements

suggests that this painting may be the urban pendant to *Cape Cod Evening* in which the collie responds to the song of the whippoorwill. Whereas in the latter painting Hopper shows how nature is taking over, in the former, *Nighthawks,* he pictures a diner that represents a move toward a mechanized future and people who still exhibit an untamed restlessness. Both situations are regarded with a jaundiced eye: nature and technology attract and repel at the same time.

The figures in *Nighthawks* could be characters in a Dashiell Hammett story. They are quiet and deliberate. Despite the number of writers who describe this painting as a meditation on desolation and loneliness, the couple appears to be completely attuned to each other. Their gestures complement one another's, and their arms and shoulders form a cohesive trapezoid that bonds them together. The feeling of desolation in the painting may stem from the architecture of the diner, the lurid lights, and the mysterious presence of the third customer. In addition, the feeling of loneliness may have originally derived from the fact that *Nighthawks* was created the year after the bombing of Pearl Harbor and the United States' entry into World War II, a time when young men were sent off to the armed services and the entire country was caught up in the war effort. The fact of the war causes one to wonder exactly who the *Nighthawks* really are. They do not seem to be local businesspeople, and they are certainly not military personnel. They appear to be outsiders, a fact underscored by the architecture and lighting of the diner, which separate them from the surrounding community of buildings.

The viewer of *Nighthawks* becomes another nighthawk, another creature who is unconnected to the reality of the war and who swarms around the brightly lit interior of the diner that both repulses and attracts and ultimately provides no possible means of entry.

In *Summertime* (1943) Hopper documents the economic upswing caused by the war, the mood of anticipation that was beginning to affect the nation, and the new relaxed morals of youth in this country. *Summertime* presents a young girl in a see-through dress standing outside a tenement. The outfit, obviously new, refers to the increased prosperity of the nation, which at last had been able to put aside many of the difficulties of the Depression. The U.S. Treasury Department estimated in 1943, the year *Summertime* was painted, that Americans at home had saved some seventy billion dollars in cash, checking accounts, and redeemable war bonds. The department's general counsel referred to this accrued money as "liquid dynamite," and his reference aptly characterizes the woman in *Summertime* and makes one think that Hopper's painting is a personification of economic renewal in this country. It is interesting to consider this painting in light of *New York Pavements* (1924), which was created two decades earli-

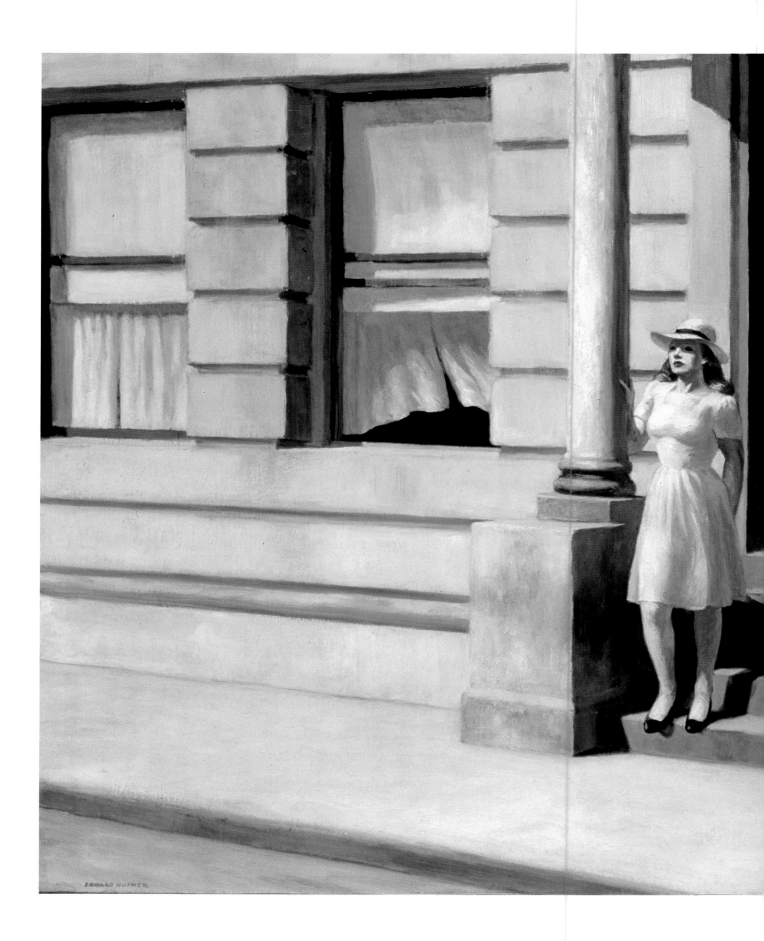

Summertime

1943. Oil on canvas, 29⅛ × 44"
Delaware Art Museum, Wilmington
Gift of Dora Sexton Brown, 1962

*Wearing a new see-through dress, the girl
represents the increased prosperity of peo-
ple in the United States in the early 1940s
who were at last able to forget the troubles
of the Depression and the uptightness of
the 1930s. The girl is alone and waiting;
the fact that she is single may be an oblique
reference to World War II and to the men
who had left to join the armed forces.*

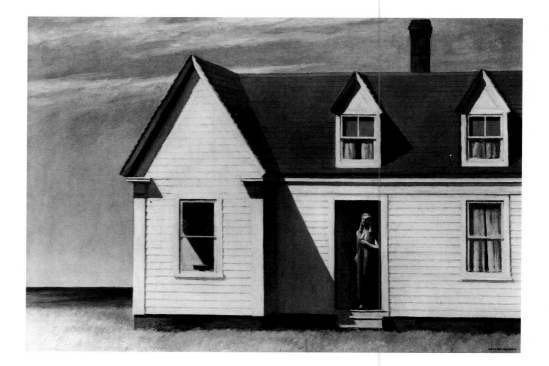

High Noon

1949. Oil on canvas, 27½ × 39½"
The Dayton Art Institute, Ohio
Gift of Mr. and Mrs. Anthony Haswell

Hopper was so concerned with getting the light right in this painting that he made a cardboard model of the house and placed it in the sunlight to be able to duplicate exactly how the light fell.

People in the Sun

1960. Oil on canvas, 40⅜ × 60⅜"
National Museum of American Art,
Smithsonian Institution, Washington, D.C.
Gift of S. C. Johnson & Son, Inc.

This picture is almost surreal in terms of the precise distance between the staggered chairs, the lack of interaction between the people, their resignation, and the fact that the light looks cold and uninviting.

er. The 1924 painting pictures an amazingly similar neighborhood; and the parallels between it and *Summertime* suggest that the baby of the earlier painting could have grown up to be the girl of 1943. Such an approach is not out of character with the Hoppers' long-term game of trying out identities for the people in the paintings. The blowing curtains of the window of *Summertime* may refer to the curtains of *Evening Wind* and might establish a poetic correspondence between the openness of the apartment window and the girl's lack of modesty. She is part of the large group of young American females who had to survive the war years as best they could, years marked by a dearth of eligible young men and an abundance of money accrued from the jobs the war effort engendered.

Many of Hopper's paintings continue concerns that he had established in the 1920s and 1930s. *Hotel Lobby* (1943) focuses on the traveler's environment, as does *Rooms for Tourists*. The former painting pictures an environment that would have been familiar to traveling salesmen, and its absence of young men suggests that it is intended as an image of the United States during World War II. In this painting, as with much of Hopper's art, that which is absent is as important as what is present. *Solitude* (1944), *Approaching a City* (1946), and *Jo in Wyoming* (1946) provide a view of a country road from a moving vehicle, a scene of a city from an approaching train, and a grand landscape which is being looked at from the stationary car of Edward and Jo, who are touring the West. These views all perpetuate Hopper's interest in the changing American landscape and his desire to make the act of looking a cultural artifact. His *Seven A.M.* (1948)

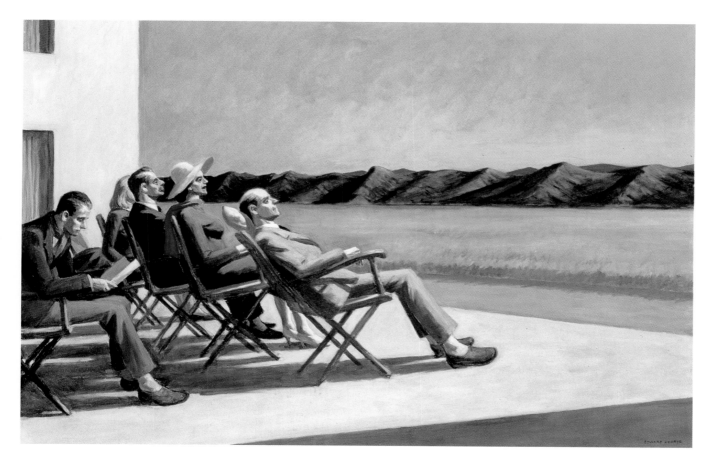

People in the Sun

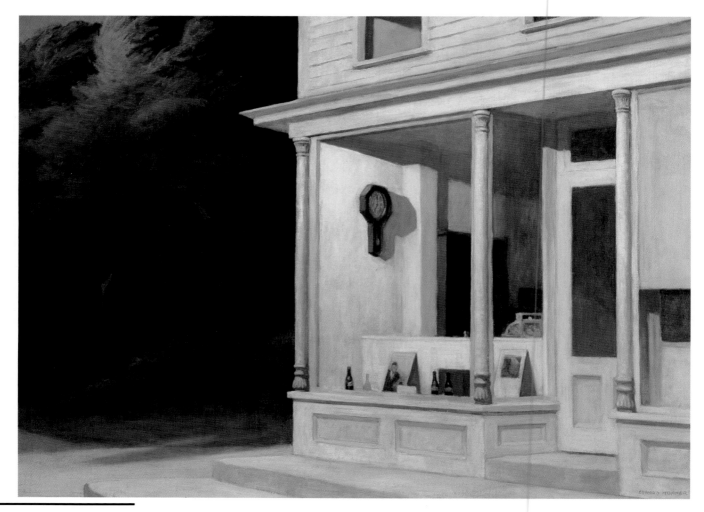

Seven A.M.

1948. Oil on canvas, 30 × 40″
Whitney Museum of American Art, New York City
Purchase and exchange
50.8

In this painting the artist captures the poetry of the prosaic and makes a small ubiquitous store emblematic of rural America. Significantly the situation Hopper paints is ambiguous: The artist does not provide the viewer with enough information to tell if the store is out of business or closed. And the bare shelves in the store and the few objects in the window do not indicate the type of business housed in this building. The painting is thus specific in terms of the time of day and general in terms of place and business. In this manner the artist elevates a common American scene into an icon.

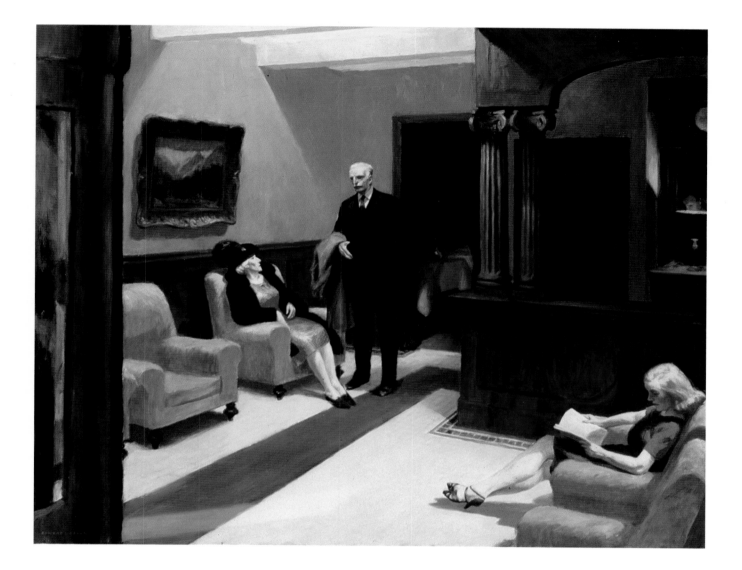

Hotel Lobby

The subject of this painting is waiting. The locale is a hotel lobby, one of the non-spaces of the modern age. Overly familiar and yet rarely looked at, the lobby of the modest hotel is viewed in terms of meetings, arrivals, and departures. As in Automat, *the viewer is characterized as a person who stares at the bright spot formed by the girl's legs.*

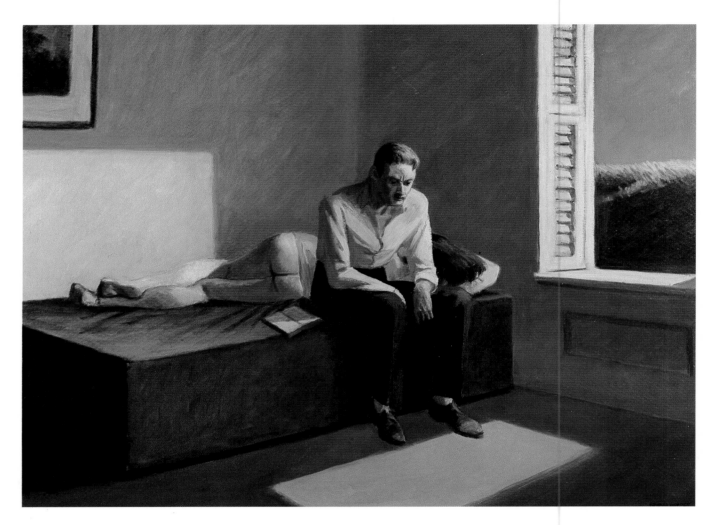

Excursion into Philosophy

sustains some of the same concerns of *Early Sunday Morning* since it continues to view middle-class America in terms of the proprietor of a small business, which in this painting is left undefined. Because there are no items on the shelves or sign at the window—only a few undesignated objects in the window display—the building could be a bar, a barbershop, or even a small grocery that is no longer operating. The old-fashioned cash register, similar to the one in the row of buildings forming a background in *Nighthawks*, again connotes the small-time businessman who customarily stands near the front door to greet customers and ring up purchases.

Two paintings of 1949 herald a deepening interest in light, an issue for Hopper that begins to assume a life of its own in his art and that becomes the major subject of his late work. Although Hopper repeatedly said that he was primarily a painter of light, one could take his proclamation as the assessment of a craftsman more than the evaluation of an artist who is concerned with developing cogent symbols of the present. But the light in *High Noon* (1949) obviously functions more as a symbol than as the light of a particular environment, and *Summer in the City* with its melancholy female, seated on a single bed staring at the floor, which is illuminated with a rectangle of sunlight, appears to use light more as a means for conveying a poetic idea than simply as a way to illuminate the room.

Light continues to fascinate Hopper in the paintings he made during the last fifteen years of his life. From *Cape Cod Morning* (1950) to *Seawatchers* and *Morning Sun* (1952) to *Sunlight in Cafeteria* (1958), *Excursion into Philosophy* (1959), *Second Story Sunlight* (1960), *People in the Sun* (1960), *A Woman in the Sun* (1961), and finally *Sun in an Empty Room* (1963), Hopper concerns himself with people who sit, stand, and wait in full sunlight or in rooms where abstract shapes of light are as visible on the walls as on the floors. In his later years Hopper regarded light as an important element that at times becomes a prosaic form of spirituality (the sunworshippers in *People in the Sun*) and sexuality (the story of the Christian Annunciation or the Greco-Roman tale of Zeus appearing to Danaë in a ray of gold coins that seems to inform *High Noon*, *Morning Sun*, and *A Woman in the Sun*).

Excursion into Philosophy suggests still another approach to light. In the ledgers, Jo recorded cryptically, "The open book is Plato, reread too late," leaving one to consider the dilemma puzzling this man who stares into an almost abstract patch of light on the floor. The woman beside him seems to be a modern, young, and very sexy muse as well as the man's lover. And the reference to Plato makes one wonder if the man is contemplating the meaning of reality and abstraction, which was certainly important to Hopper, who by the 1950s had been subjected to many statements by abstract artists about the role light played in their work. Since Plato praised the

Excursion into Philosophy

1959. Oil on canvas, 30 × 40″
Richard M. Cohen
Beverly Hills, California

In her ledger, Jo Hopper cryptically summed up this painting: "The open book is Plato, reread too late." Since Plato praised the realm of ideas as the ultimate form of reality and relegated physical manifestations of them to a lower realm, the man in the painting seems to be questioning the idea of light versus actual rays of it and the idea of beauty versus the presence of the voluptuous female on the bed beside him.

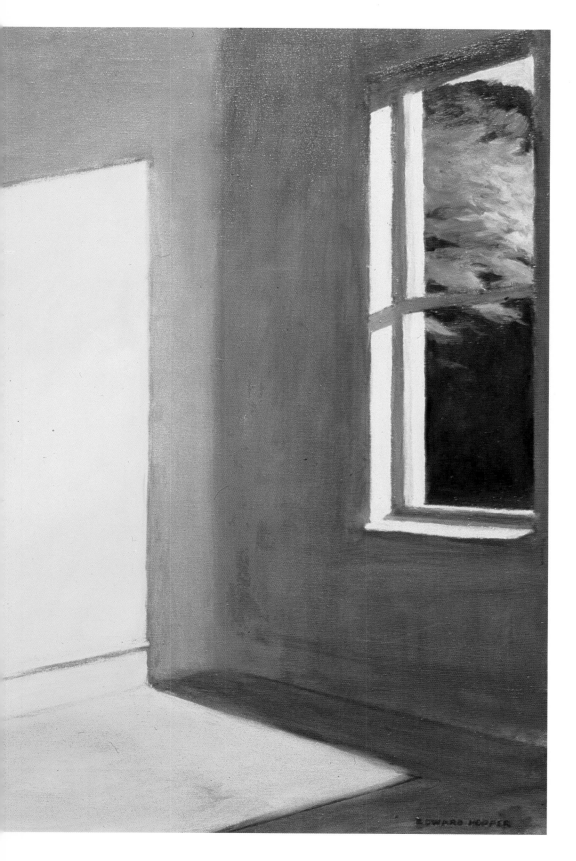

Sun in an Empty Room

1963. Oil on canvas, 28¾ × 39½"
Private collection, Washington, D.C.

In one of his last works, Hopper focuses on a barren room accentuated by light. Light functions as both illusion and abstraction, a way of illuminating a scene and possibly symbolizing enlightenment.

realm of ideas as the ultimate form of reality and relegated physical manifestations of them to a lower realm, the man in the painting seems to be questioning the idea of light versus an actual beam of it and the idea of beauty versus the presence of the voluptuous female on the bed beside him. One wonders if Hopper has attempted to condense the question of light, which occurs in so many of his works, into the Platonic argument. In his story about Socrates and the cave, Plato compares works of art to the shadows cast by ordinary objects that in themselves are only pale reflections of the true reality which is the realm of ideas. And in *Excursion into Philosophy* Hopper counters Plato's mere shadows with a block of light which pictures itself and which symbolizes the potential of understanding (illumination).

The last two paintings in Hopper's series dealing with light, *A Woman in the Sun* and *Sun in an Empty Room*, underscore the symbolic aspects of his art by alluding to light as spirituality and also by referring to the age-old symbol of the soul as a house or room. These works suggest the malaise of the modern world. The woman in the first painting (see pp. 12–13) appears to be a modern-day Olympia, a figure who is naked by virtue of the fact that being clothed is her natural state, a fact attested to by the black pumps beside the bed. (It is noteworthy that Hopper once copied Manet's *Olympia*, who is naked except for black shoes.) The woman stands resigned in the light and holds a cigarette. She seems to accept as her fate whatever the light represents. The waving curtain on the right, which harks back to *Evening Wind*, indicates that this painting might be a secularization of the Annunciation or a modern-day portrait of Danaë, but the middle-aged woman appears to be no virgin—even though she sleeps in a single bed—and she is too old to be a temptress of the ancient gods. Although she is illuminated by the light, she seems to be more a part of the shadowy room; enlightenment, inspiration, knowledge—whatever the light symbolizes—is a momentary condition for both this woman and the enclosed space. The soul symbolized in *Sun in an Empty Room* is as desolate as *A Woman in the Sun;* both paintings picture a hopeless, barren situation.

Although light becomes a symbol in *Excursion into Philosophy*, many of Hopper's late works refer to the popularity of sunbathing and the leisure resulting from the new prosperity of the booming postwar economy, while others appear to be concerned with the lethargy and depression often experienced by people who have been traumatized by too much change. In addition, many of these paintings of people staring at light manifest a feeling of aftermath, the strain and feeling of loss experienced by a generation of men and women who once felt important because of their contributions to the war effort. Accentuating the sense of passive waiting that characterizes these paintings is the fact that the Cold War,

Morning Sun

1952. Oil on canvas, 28⅛ × 40⅛"
Columbus Museum of Art, Ohio
Museum Purchase, Howald Fund

As in many other works, Hopper suggests warm weather and then creates a cold, wintry light to convey the idea of isolation and alienation.

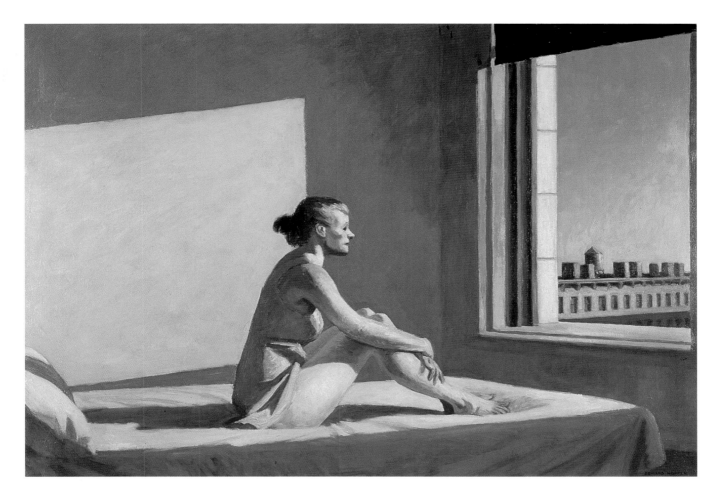

Morning Sun

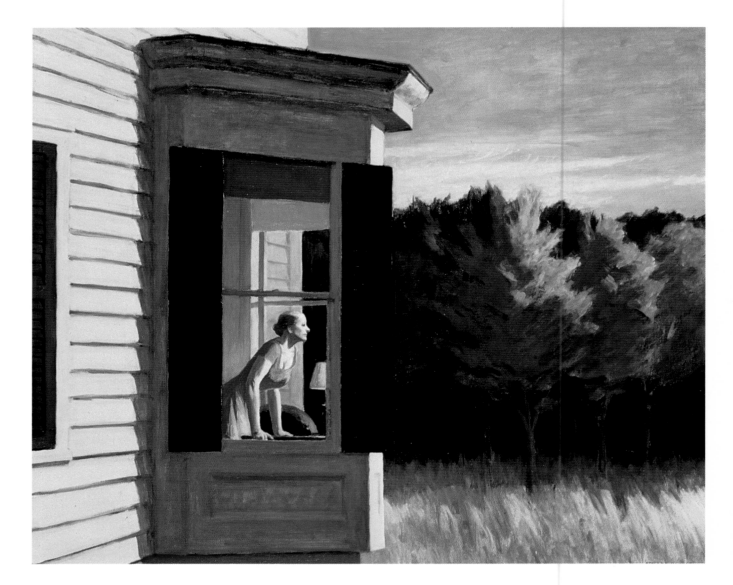

Cape Cod Morning

Solitude

1944. Oil on canvas, 32 × 50″
Private collection

This painting is another of Hopper's compositions focusing on the theme of the road. Solitude *refers to the landscape and possibly to the viewer, a motorist who may be escaping by going on a drive in the country.*

then at its height, seemed to preclude any successful resolution and instead suggested a possible holocaust for everyone. The trauma of the Cold War caused many people to become weary of politics and to seek relief in mindless diversions. Their means of escape seem to provide little relief from the apathy that affected this generation, an apathy central to many of Hopper's paintings and to the postwar science fiction films dealing with the end of the world. In considering these paintings it is important to point out that they were made by a man nearing the end of his life, and also important to note that he does not sentimentalize his subject. He remained as steadfastly realistic as he had been in the 1920s when he refused to believe in the great new modernist faith that so many of his compatriots had celebrated. He had worked to remain a realist in the twenties and had managed to survive the Great Depression and World War II without becoming bitter in the former and overly patriotic in the latter. In the fifties and sixties he was able to continue to synthesize his impressions so that they presented facts without succumbing to either propaganda or mawkish sentiment. He had the good sense to find equivalences for his feelings in situations, places, and scenes, to continue to be excited by light, human beings, and the differences in generations, and to record apathy as just another aspect of modern life.

His *Second Story Sunlight,* for example, communicates his feelings for people, his ability to continue to be excited by the female body, and to become entranced with the new teenage phenomenon that was characterizing the 1950s and 1960s. "Toots" (his name for the young girl) is full of

Cape Cod Morning

1950. Oil on canvas, 34⅛ × 40⅛″
National Museum of American Art,
Smithsonian Institution, Washington, D.C.
Gift of Sara Roby Foundation

Features of Cape Cod Evening *are continued in this painting: the encroaching forest, the lawn that has become a field, and a Victorian house that connotes a gracious style of living, which is no longer being perpetuated.*

Drawing for painting
Two Comedians

1965. Charcoal on paper, 8½ × 11″
Private collection

*This early study shows the two Hoppers
offstage and behind the audience perform-
ing an entr'acte.*

life. She sits on the second story balcony taking in the sun and waiting for
the hot rods that would be cruising the neighborhood. She is just as eager
to get off the balcony and join the mad rush of modern life as the old wom-
an is content to remain there and watch life go by. The teenager in this
painting points to an important new force in the postwar era. And Hop-
per's delight in her is not that different from his fascination with the legs of
the woman pictured in *Automat* almost forty years before.

Hopper was aware of his oncoming death. He was ill for some time,
and he symbolized his passing by creating a farewell picture entitled *Two
Comedians* (1965), which, according to Jo, presented the two of them bid-
ding farewell like "two small figures out of pantomime." In the painting,
the tall comedian bows and gestures to the female, who shyly stands a little
behind him and points back to him. The painting affirms that the art on
one level was a collaborative venture, a process of Edward Hopper think-
ing up possible roles for Jo, which she then acted out so that he could paint
them.

Although Hopper emphasized vision as a historical fact that indicates
new orientations for twentieth-century viewers, his last painting reaffirms
the very traditional orientation of the proscenium stage theater. In a pre-
liminary sketch he considered placing himself and Jo at the rear of the the-
ater so that they would become an entr'acte, but he decided in the painting
to make their leavetaking more traditional and to move from his usual po-
sition behind the viewer and to go up to the stage and take his bow as a re-
tiring performer. His final act as a painter was to let his viewers know that
art and life are part of a grand play in which the artist and his wife have
been primary actors, thus paralleling Shakespeare's famous lines, "All the
world's a stage/and all the men and women merely players./They have
their exits and their entrances/and one man in his time plays many parts."

Two years after completing *Two Comedians,* Edward Hopper died; a
year later his wife, Jo, followed him.

Two Comedians

1965. Oil on canvas, 29 × 40″
Private collection

*According to Jo, the couple pictured here is
the Hoppers bidding farewell like "two
small figures out of pantomime." The
painting was Hopper's last work, his for-
mal leavetaking of art and life.*

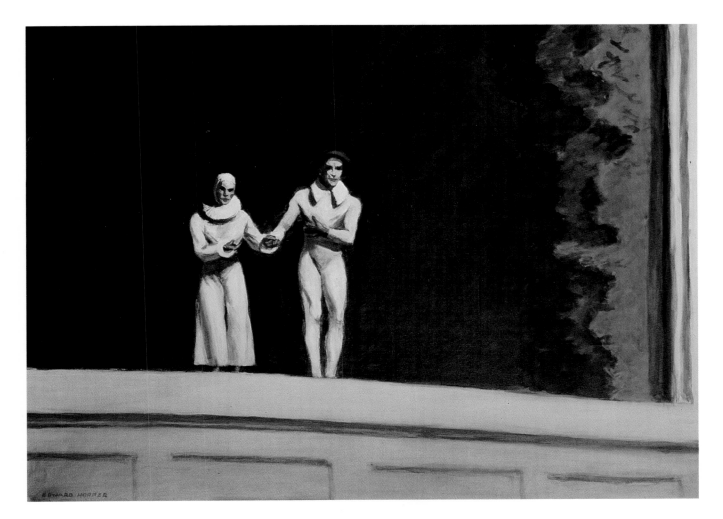

Two Comedians

Edward Hopper in front of his house in South Truro, Massachusetts; Josephine Hopper in the distance.
August 1960. Photograph by Arnold Newman

Chronology

1882 Born July 22 in Nyack, New York, to Garrett Henry Hopper and Elizabeth Griffiths Smith Hopper

1899 Graduates from Nyack High School and studies illustration at the Correspondence School of Illustrating, New York City

1900–
1906 Enters New York School of Art and studies illustration with Frank Vincent Du Mond and Arthur Keller and painting with William Merritt Chase, Robert Henri, and Kenneth Hayes Miller. Classmates include Gifford Beal, George Bellows, Patrick Henry Bruce, Clarence K. Chatterton, Guy Pène du Bois, Rockwell Kent, Vachel Lindsay, Walter Pach, Eugene Speicher, Carl Sprinchorn, and Clifton Webb

1906–7 Works briefly as an illustrator at C. C. Phillips & Company before going to Paris. Stays in Europe for eleven months and travels to London, Amsterdam, Haarlem, Berlin, and Brussels. Sails for New York City in August 1907 and works as a commercial artist. Begins to exhibit his work

1908 Exhibits in group show at the Harmonie Club in New York City, which includes work of other Henri students

1909 Second trip to Paris, where he lives and works for five months

1910 Included in "Exhibition of Independent Artists," New York City, organized by Arthur B. Davies, Robert Henri, and John Sloan. Makes final trip to Europe, where he stays for one and a half months. Visits Paris, Madrid, and Toledo. Returns to New York City and continues work as a commercial artist. Paints in his spare time

1912 Summers in Gloucester, Massachusetts

1913 Included in the Armory Show with painting entitled *Sailing*. Moves to 3 Washington Square North in New York City

1914 Summers in Ogunquit, Maine, where he returns in summer of 1915

1915 Begins to etch and creates fifty-two plates over the next thirteen years

1916 Paris watercolor caricatures reproduced in *Arts and Decoration*. Summers in Monhegan Island, Maine, where he returns to summer in 1917, 1918, and 1919

1918 Exhibits etchings at the Chicago Society of Etchers

1920 First one-person exhibition, Whitney Studio Club, New York City

1921	Included in annual exhibition of Whitney Studio Club and in succeeding exhibitions over the next four years
1922	Exhibits Paris watercolor caricatures at Whitney Studio Club
1923	Recipient of Logan Prize, Chicago Society of Etchers. Summers in Gloucester, Massachusetts, where he returns to summer in 1923, 1924, 1926, 1928
1924	One-person exhibition of watercolors, Frank K. M. Rehn Gallery, New York City; show sells out. Marries Josephine Verstille Nivison on July 9. Residence remains 3 Washington Square North
1925	Summers in James Mountain, Colorado, and Santa Fe, New Mexico
1926	Included in the "Today in American Art" group exhibition, Frank K. M. Rehn Gallery. Is given one-person exhibition of watercolors and etchings, St. Botolph Club, Boston. Summer trips to Eastport, Bangor, and Rockland, Maine, and Gloucester
1927	Purchases Dodge automobile. Summers at Two Lights, Cape Elizabeth, Maine, and returns in summer of 1929
1929	One-person exhibition of drawings, watercolors, and oils, Frank K. M. Rehn Gallery. Included in "Paintings by Nineteen Living Americans" exhibition, The Museum of Modern Art. Trips to Charleston, South Carolina, and to Vermont, where Hoppers return for brief stays over the years
1930	Summers in South Truro, Massachusetts, on Cape Cod. Rents Burly Cobb's house and returns for summers in 1931, 1932, and 1933
1932	Declines Associate Membership to National Academy of Design. Whitney Museum of American Art Biennial (the beginning of a long association with Whitney Biennials and Annuals)
1933	Retrospective exhibition, The Museum of Modern Art. Trips to Quebec Province, Canada, Ogunquit and Two Lights, Maine, Boston, and South Truro. Purchases land in South Truro
1934	Retrospective, Arts Club of Chicago. Builds combination house and studio in South Truro in summer and returns there to summer almost every year for the rest of his life
1935	Recipient of Temple Gold Medal, Pennsylvania Academy of Fine Arts, and First Purchase Prize in watercolor, Worcester Art Museum, Massachusetts
1937	Recipient of first W. A. Clark Prize and Corcoran Gold Medal, Corcoran Gallery of Art, Washington, D.C.
1940	Automobile trip to Colorado, Utah, Nevada, California, Oregon, and Wyoming
1942	Recipient of Ada S. Garrett Prize, The Art Institute of Chicago
1943	Train trip to Mexico
1945	Recipient of Logan Art Institute Medal and Honorarium, The Art Institute of Chicago. Election to National Institute of Arts and Letters
1946	Automobile trip to Saltillo, Mexico, and to Grand Tetons

1950 Retrospective exhibition, Whitney Museum of American Art; show tours to Museum of Fine Arts, Boston, and Detroit Institute of Arts. Honorary degree, Doctor of Fine Arts, The Art Institute of Chicago

1951 Third trip to Mexico and brief stay at Santa Fe

1952 One of four artists chosen by American Federation of Arts as United States official representation at Venice Biennale. Fourth trip to Mexico (December 1952–March 1953)

1953 Honorary degree, Doctor of Letters, Rutgers University

1954 Recipient of First Prize for Watercolor, Butler Art Institute, Youngstown, Ohio

1955 Recipient of Gold Medal for Painting presented by National Institute of Arts and Letters for American Academy of Arts and Letters. Fifth trip to Mexico

1956 Recipient of Huntington Hartford Foundation fellowship for six months at Foundation headquarters, Pacific Palisades, California (December 1956–June 1957)

1957 Recipient of New York Board of Trade's Salute to the Arts Award and First Prize, Fourth International Hallmark Art Award

1959 One-person exhibition, Currier Gallery of Art; show tours to Rhode Island School of Design

1960 One-person exhibition, Wadsworth Atheneum, Hartford, Connecticut. Recipient of *Art in America* Annual Award

1962 Retrospective exhibition of graphic work, Philadelphia Museum of Art; show tours to Worcester Art Museum, Massachusetts

1963 Retrospective exhibition, Arizona Art Gallery. Recipient of Award from St. Botolph Club, Boston

1964 Retrospective exhibition, Whitney Museum of American Art; show tours in 1965 to Art Institute of Chicago, Detroit Institute of Art, and City Art Museum, St. Louis. Recipient of M. V. Kohnstamm Prize for Painting, Art Institute of Chicago. Illness prevents Hopper from painting

1965 Honorary degree, Doctor of Fine Arts, Philadelphia College of Art. Executes last work, *Two Comedians*

1966 Recipient of Edward MacDowell Medal

1967 Dies May 15 in his studio in New York City

Selected Bibliography

BARR, ALFRED H., JR. *Edward Hopper: Retrospective Exhibition.* New York: The Museum of Modern Art, 1933.

GOODRICH, LLOYD. *Edward Hopper.* Harmondsworth, England: Penguin Books, 1949.

————. *Edward Hopper: Retrospective Exhibition.* New York: Whitney Museum of American Art, 1950.

————. *Edward Hopper: Exhibition and Catalogue.* New York: Whitney Museum of American Art, 1964.

————. *Edward Hopper.* New York: Harry N. Abrams, 1971. Reprinted 1983.

————. *Edward Hopper: Selections from the Hopper Bequest to the Whitney Museum of American Art.* New York: Whitney Museum of American Art, 1971.

HOPPER, EDWARD. "Books" (review of Malcolm C. Salaman, *Fine Prints of the Year 1925*), *The Arts,* 9 (March 1926), pp. 172–74.

————. "John Sloan and the Philadelphians," *The Arts,* 11 (April 1927), pp. 168–78.

————. "Books" (review of Vernon Blake, *The Art and Craft of Drawing*), *The Arts,* 11 (June 1927), pp. 333–34.

————. "Charles Burchfield: American," *The Arts,* 14 (July 1928), pp. 5–12.

————. "Edward Hopper Objects" (letter to Nathaniel Pousette-Dart), *The Art of Today,* 6 (February 1935), p. 11.

————. "Statements by Four Artists," *Reality,* 1 (Spring 1953), p. 8.

KUH, KATHERINE. *The Artist's Voice: Talks with Seventeen Artists.* New York: Harper & Row, 1962.

LEVIN, GAIL. *Edward Hopper as Illustrator.* New York: W. W. Norton & Company in association with the Whitney Museum of American Art, 1979.

————. *Edward Hopper: The Complete Prints.* New York: W. W. Norton & Company in association with the Whitney Museum of American Art, 1979.

————. *Edward Hopper: The Art and the Artist.* New York: W. W. Norton & Company in association with the Whitney Museum of American Art, 1980.

————. (guest editor). *Art Journal,* Summer 1981, vol. 41, no. 2. Special issue publishing proceedings of Edward Hopper Symposium at the Whitney Museum of American Art.

O'DOHERTY, BRIAN. *American Masters: The Voice and the Myth.* New York: Random House, 1973.

————. "Invitation to Art." (Interview with Edward and Jo Hopper.) Museum of Fine Arts, Boston, with WGBH-TV, Boston, 1961. (Typescript in possession of the Whitney Museum of American Art.)

RODMAN, SELDEN. *Conversation with Artists.* New York: The Devin-Adair Company, 1957.

ZIGROSSER, CARL. "The Etchings of Edward Hopper," in *Prints,* edited by Carl Zigrosser. New York: Holt, Rinehart, and Winston, 1962.

Photograph Credits

The author and publisher wish to thank the museums, galleries, libraries, and private collectors who permitted the reproduction of works of art in their possession and supplied the necessary photographs. Photographs from other sources (listed by page number) are gratefully acknowledged below.

Lee Brian, Palm Beach: 138; Geoffrey Clements, New York: 17, 32, 37, 44–45, 90, 94, 95, 105, 136; Bill Jacobson, New York: 100–101; James Maroney, New York: 21; Museum of Fine Arts, Boston: 15; Eric Pollitzer, New York: 118; John Tennant, Washington, D.C.: 128.

Index

Page numbers are in roman type. Page numbers on which illustrations appear are in *italic* type. All paintings are by Hopper unless otherwise noted.